BUSINESS BELIEFS

UPGRADE YOUR MINDSET TO OVERCOME
SELF-SABOTAGE, ACHIEVE YOUR GOALS, AND
TRANSFORM YOUR BUSINESS (AND LIFE)

HOLLY WORTON

ISBN 978-1-911161-29-5

First edition: 2016
Second edition: 2020

Published by Tribal Publishing Ltd

Please direct permissions requests to:
permissions@tribal-publishing.com

CONTENTS

INTRODUCTION TO THE SECOND
EDITION

"You have to believe. Otherwise, it will never happen."

— Neil Gaiman, Stardust

When I first conceived the idea of this book, it was to create a free opt-in gift for my website. Even before I started writing it, I realized I was thinking too small, and I wanted to get the book out in a more significant way so that I could help more people with their business beliefs. And the way I saw to do that was by releasing this book through a variety of ebook platforms and online retailers so that people who were new to my work could get the help that they needed.

This book, *Business Beliefs*, was my first business mindset book, and since then, I have released three others, all complementary to this one: *Business Blocks*, *Business Visibility*, and *Business Intuition*. I've received great feedback from all the books, and I'm currently planning to release the second editions of all four.

Just over a year after releasing *Business Beliefs*, I decided to put together a new edition. At that point, I was working with

clients differently, using a new technique that works not just at the subconscious level, but also at the energetic level, making it fast-acting and powerful. Clients were experiencing significant changes and fast results. I wanted to share this with readers because I now had a whole new perspective on business beliefs. I was also working more with intention: creating rich and detailed goals and beliefs, and helping clients to program these intentions into their subconscious, while simultaneously releasing any energetic blocks they might have.

However, I continued to work with specific belief statements, such as those you'll find in this book. It's a fast and easy way of changing our mindset. There are many mindset-changing processes and techniques that work with belief statements, which is why I've included even more of them in this second edition. I've added extensively to the lists with new belief statements that I've created over the past years with myself and my clients. Working with specific belief statements is an easy way of reprogramming your beliefs, and belief statements are a great way to begin transforming your mindset.

If, however, you work with a more intention-focused process, such as my Heart-centered Energy Work® technique, you can easily integrate these belief statements into the overall goal. I'll show you exactly how to use these belief statements to create a specific intention in a later chapter. Then, you can use that intention in your mindset work.

Eventually, I pressed pause on my one-to-one client work so that I could focus on my writing, and that's where I am today. I'm offering minimal client calls at this time, but I know several skilled facilitators who can help you with your business mindset, should you prefer to get one-to-one help with your business beliefs. More on that in a later chapter.

∾

You may find it odd that I've started this introduction to the second edition with a quote from a fantasy novel. But it's the perfect quote for the topic of business beliefs. If you don't believe in yourself and in your ability to create a successful business, then it's not going to happen, no matter how hard you work. I struggled with that myself for years, and I've seen my clients experience the same challenges.

That's why business mindset is so important to me: when we align our beliefs with our business goals, taking action becomes so much easier. It's like the secret sauce to business. It allows us to release our fears, blocks and limiting beliefs so we can move forward with ease.

Our beliefs are the foundation of our mindset. If they do not support us, they will hinder us and our ability to make things happen in our business ventures. They make it hard to build our company, to get clients, and to charge prices that accurately reflect our ability to help people. These limiting beliefs keep us stuck in a cycle of self-sabotage.

If you've been struggling to build your company, your beliefs may be getting in the way. Unfortunately, mindset work is often the last thing that struggling entrepreneurs consider. They think they need to do more training, sign up for the latest online course, or hire a big-name coach. These things are all great and can certainly be helpful, but if your beliefs aren't in order, then you probably won't get the significant results you're hoping for. I haven't gotten as much out of some of my past investments in coaching and mentoring because the beliefs I had at the time weren't supportive. My business mindset was wracked with self-doubt, low self-esteem, and low self-confidence.

Mindset work is so, so important. It's been *the* number one action that's enabled me to grow my business because it's helped me to release my fears and blocks and finally step into my greatness after years of playing small and struggling with

visibility. Doing the mindset work has enabled me to more easily take the practical action I needed to take to grow my business. It's helped me to stop procrastinating and start taking action toward my business goals.

Shifting these business beliefs will create ripples that go far beyond your business: they'll enhance every aspect of your life, allowing you to create the life you want more quickly and easily. Transforming your business beliefs will not only change your business; it will change your life.

Getting your beliefs aligned with your vision and your goals for your business makes everything easier. You can push, and you can hustle, and you can burn yourself out—or you can transform your beliefs and take easy inspired action toward your goals. Which do you prefer?

It's like the difference between water trying to push through a dam or flow smoothly over the stones in a river. The dam is your fears, blocks, and limiting beliefs. The smooth flow is your supportive mindset. Fortunately, it's easy to dismantle the barrier so you can allow your business to flow more freely.

If you're reading this book, I'm going to assume you prefer the latter. I look forward to taking you on a journey to explore your current business beliefs and how they're currently serving you—or hindering you—in your business and your life. Let's get started!

INTRODUCTION TO THE FIRST EDITION

"Live your beliefs and you can turn the world around."

— HENRY DAVID THOREAU

I'm so excited that you've started reading this book and are taking the first step to release the blocks that are holding you back from creating the business of your dreams. I've been in business since 1999, and I know firsthand what it's like to battle those inner gremlins that can hold us back from achieving our dreams. They can be crippling, keeping us stuck and frustrated in our business.

Sometimes they're obvious, sending us clear messages:

- You're not good enough!
- No one will pay what you're asking. What, are you crazy?
- You just need to take one more training course (or business course, or marketing course. . .the choices are endless), and *then* you'll know enough to start charging clients.

- Online marketing isn't for you. . .it's just too scary. Besides, you're not good at technology.
- No one will want what you have to offer. You're nothing special. It's been done before.

And sometimes they're not so obvious. . .

There are times when we aren't consciously aware of that negative mind chatter, but there's something that's holding us back. Something that we can't quite put our finger on, because we don't even know what it is: we're just feeling stuck and frustrated. It might be that we have limiting beliefs stuck deep in our subconscious mind, working on a level we can't easily access. They're just silent, invisible blocks, and they may have been there your entire life, deep in your subconscious mind.

And this is what makes it frustrating: most of us aren't used to accessing our subconscious mind on a regular basis. It's not something our parents teach us, and it's certainly not something we learn in school or even university. It's the kind of thing you have to do special training to learn. . .*if* you're aware that such a thing is possible. Many people have no clue that this kind of thing is going on in their lives.

When we are able to access these fears, blocks, and limiting beliefs and get clear on exactly what's holding us back, or how we're self-sabotaging, then we know what we're working with. We know exactly what we need to change in our mindset, and from there, it's just a matter of choosing *how* we want to transform those beliefs. Because, believe me, it's possible.

I know because I've done it. And I make it happen every day with my clients.

1

PURPOSE OF THIS BOOK

"Whether you believe you can do a thing or not, you are right."

— HENRY FORD

My intention for this book is that it will help you to identify the core beliefs that you can benefit from shifting in your business mindset. This in itself is huge: accepting and identifying limiting beliefs is the first step on the path toward transforming your business mindset. If you're unaware of what your current business beliefs are—and whether or not they're serving you—then you don't know what's keeping you stuck.

The next step is to understand that these beliefs can be changed. It's easy to transform your beliefs, and depending on the process or technique that you use; it can take as little as 2–5 minutes. When we work on our mindset at the deeper levels—the energetic and the subconscious—significant change can happen quickly and easily.

The final step in changing your beliefs is to do the work to

transform these beliefs into useful ones. There are so many processes and techniques that can help you to change your mindset at the deeper levels easily, and we'll talk more about these in a bit. It's essential to work on your mindset at the subconscious and energetic levels, which is how you create lasting change.

There's another step that comes after you've changed your beliefs, and that's taking action. While transforming your beliefs and your mindset is incredibly powerful and life-changing, you still need to take practical action to see the changes you want to see in your business. Mindset work and practical action go hand-in-hand.

Working on your conscious beliefs is better than doing nothing, but it's much work for little results. If your subconscious mind isn't on board with your conscious beliefs, you'll stay stuck. And if you have blocks in your energy field, you won't make much progress, either.

All you need is to learn how to do this work yourself or find someone who is trained in doing this work. Ideally, you'll want to do both: train in a process or technique yourself so you can work with your business mindset on a daily or weekly basis, and then get additional help from another professional when needed—more about that in the chapter on Moving Forward.

This is how I work with my business mindset, and this is how I've seen my clients get the best results. The benefit of being able to do this work on your own is that you can do it whenever you need to, even daily, as I often did at the beginning of my journey. The benefit of working with another professional is that they can usually help you to dig deeper and see things that you can't manage to see on your own. For me, it's the perfect combination that helps to create lasting mindset change—and significant transformations in my business.

Once you've done the mindset work to change your beliefs, you're ready to take the right actions for your business more

easily. When your beliefs are aligned with your vision and your goals, you *know* which are the right actions to take. And it's much, much easier to do it. Procrastination goes out of the window.

If your business isn't working, it's probably not because you need to learn more about running a business. I'm going to assume that if you're reading this book, then you're not new to the business world and that you do have at least a basic grasp on how to own and operate a business. If not, that's easy enough to learn. There is so much information online about how to set up, build, and run a business.

If you understand business and yet you *don't* have the business and lifestyle that you dream of, then you're probably sabotaging your efforts with your current business mindset. If you're feeling stuck and frustrated with your business, it's time to take a look at your business beliefs, because it's often the mindset stuff that holds us back. Or if you're living someone else's dream and you've forgotten about your own, I'm here to help you change that.

This book serves as an introduction to business beliefs and how they influence our business mindset. I designed it to help you get going on the road to transforming your beliefs, so they work *with* you, not *against* you. You've got everything you need in here to get started.

What do you want?

But for now, let's focus on what *you* want. What exactly do you want to get out of reading this book? What are you hoping to achieve?

Stop reading for a minute, think about this, and then write down your answer somewhere. It's important to know what you want to get out of this book because then you'll be more likely to achieve it. It's also essential to *write it down*, for three reasons:

1. It helps you clarify your goals
2. It enables you to commit to these goals
3. It helps you to see whether you have achieved these
 goals once you've finished reading this book and
 have taken action on the information it contains.

I need to clarify right now that this book is *not* a self-help book: it's not designed for you to read it and feel all warm and fuzzy about your business and then put it back on your shelf and keep doing the same things you've been doing. It's designed for you to *take action* on the information I've provided in this book so that you can do the work to transform your business beliefs.

Warning: **if you read this book and don't take action, don't expect much in terms of results. I cannot stress this enough. You've got to do the actual mindset work of shifting your beliefs...***and* **you've got to take practical action. You need to be the change you want to see in your business.**

Who is this for?

This book is for business owners and entrepreneurs of all levels who are feeling stuck and frustrated with their business. It's also for professionals who work with clients who are feeling stuck. Maybe you're new to the concept of business mindset. Or perhaps you've got some experience working with beliefs and mindset, but you're not sure where to go from here. Maybe you already work with mindset and belief statements, and you need a list of business-related statements for inspiration. Or perhaps you've been in business for years—decades, maybe—and yet something's not quite right.

I co-founded my first company in 1999 (eco-hotels in Latin

America), and I didn't discover this deep level of mindset work until 2013. When I started doing this work with myself, it fast-tracked my transformation in a big way, despite the fact that I already had 14 years of business under my belt at the time. It's never too late to start working on your business mindset. And if you're learning about this now for the first time, then congratulations! That means that now is the perfect time for you to do this work.

Wherever you are on your entrepreneurial journey, this extensive list of beliefs will help stimulate your exploration of what's holding you back from creating a successful, sustainable venture—and also the lifestyle of your dreams. It's never too late to get started working on your mindset. I started doing this work in 2013, when I was 40 years old! The deeper you dig to discover your limiting beliefs, the more likely you are to find the core of the issue that's stopping you from having that dream business today. Sometimes, we need to "wake up" so we can fulfill our dreams. This book is designed to help you do just that.

You're in the right place if:

- You're feeling frustrated with your business, and you know you need to do something different. . .but you don't know what.
- You know your business mindset needs some upgrading to help you step into your greatness and get your business to the next level.
- You're sick and tired of your negative mind chatter always dragging you down.
- You're willing to take an honest look at what might be holding you back.
- You're ready to take action to transform your

business mindset, which will also lead to changes in your personal life. It's all connected!

This book is not for you if:

- You expect to get big results from just reading a book and not taking any action.
- You're not willing to go deep to look into the shadow side of your beliefs and how they might be affecting you.
- You want a successful business, but you're not willing to do what it takes to get there.

2

HOW TO USE THIS BOOK

I f you're new to the concept of identifying and transforming beliefs, then you probably want to read through each chapter before perusing the lists of belief statements. It will give you an idea of the importance of working at the deeper levels when transforming your mindset, and it will provide you with an introduction to beliefs and how they affect you.

If you're already experienced in a process or technique that works to change beliefs, such as PSYCH-K®, you may want to skip straight to the lists of belief statements that begin in Chapter 13. You may even want to print out the pages containing the belief statements, so you can use them with yourself or with clients to help transform business beliefs.

If you've purchased the ebook edition of this book, you might want to consider getting the print edition and also the workbook. While I love reading ebooks, I find it most comfortable to read nonfiction in print. That way, I can underline passages and make notes in the margin—and then have the book on hand to use as a reference.

The workbook includes some necessary information from

most of the chapters, plus all of the belief statements for you to work with. It also has journal prompts to help you explore your own limiting beliefs so you can create your belief statements, and it has plenty of space to write them down. It provides plenty of space for exploring your mindset, and it will help you to take this work even more in-depth.

If you have any questions, please get in touch via my website: www.hollyworton.com. I love hearing from readers.

ABOUT ME

"Your intuition knows what to do. The trick is getting your
head to shut up so you can hear."

— LOUISE SMITH

For many years, I was a business mindset coach for
women entrepreneurs. I worked with women who
were feeling stuck and frustrated because they felt like
they were hitting a plateau in their business. Maybe they were
struggling to get a steady stream of clients, or perhaps they
wanted to grow their business to a new level. My work was to
help them release their fear of visibility, set aligned prices for
their products and services, and take inspired action to grow
their business.

Today, I've taken a step back from one-to-one sessions so I
can focus on my writing. I've learned a lot from my years of
coaching and mindset work with clients that I want to share in
a more significant way through my books.

I'm dedicating this chapter to sharing my business journey
with you so that I can clearly explain how changing my

mindset has completely transformed my business and my life. That way, you'll understand *why* I do what I do: business mindset has been one of my biggest life lessons. My life—and business—can be divided into two phases:

1. Before I discovered mindset work
2. After I discovered mindset work

It's also crucial for me to tell you my story so you can get an idea of just how powerful it is to change your business mindset at the subconscious and energetic levels. I went from a place of having extremely low confidence and low self-esteem to being sure of myself and proud of what I do. Mindset work is profound work, and it can create significant results in very little time.

I know what it's like to struggle to build a business on my own. That's why I worked in the field of business mindset for so long. I know how it feels to be doing all the right things, and yet not achieve my goals. And I know what it's like to experience significant changes once I started doing the mindset work by transforming my beliefs at this profound level.

My first company

I've been an entrepreneur since 1999. My first company, which was in the hospitality industry, was a constant uphill struggle as I learned new business and marketing skills. I was in a state of continual learning and expansion, which was both exciting and exhausting. I had quit my graduate studies in literature at UCLA to start the company with a business partner in Latin America.

Despite having zero experience in hospitality, my business partner and I managed to build a wildly successful business. We went from four small cabañas on the beach to owning and

operating three ecological hotels in southeast Mexico, with a second property in development in Patagonia, and a central office in Buenos Aires that managed sales, reservations, and marketing.

Our hotels in Mexico were cutting edge: we were the first in the area to embrace and promote the concept of eco-travel, and we were the first to create a holistic spa featuring local Mayan healers and massage therapists. The resort was such a big part of our business that we used to say we had a "spa with hotels" rather than "three hotels with a spa."

We were a media darling. Editors from significant travel and spa publications came from all over the world to feature our properties. International celebrities came to stay with us—some returning for a second or third visit.

My primary role in the company was in the area of online marketing. We built our first website in 1999, and I soon started using pay-per-click advertising on Goto, which later became Overture and eventually Yahoo! Search Marketing (this was long before Google AdWords, or even Google, for that matter). Our marketing was also cutting edge compared to other hotels in the area. We fully embraced technology—despite being located in the jungle—and we focused our efforts on driving traffic directly to our website. We consistently brought more than 80% of our reservations, drastically reducing costs because we didn't have to pay much in travel agent commissions.

The business also spread and grew through word of mouth. One evening, I was hanging out near the front desk and asked a guest how they heard of us. To my surprise, he told me that he had been at a party in San Francisco and had met someone who had just returned from our hotel. They were so effusive in their praise that the man went straight home and booked a stay with us.

We regularly heard from guests about how their lives had

been changed by their holiday at our properties. Our seaside cabañas were candlelit, surrounded by native jungle, allowing guests to disconnect from their day to day hustle and enter a state of deep relaxation and recovery from stress. We had created something unique, and other hotels within the region began to copy us. These copycats were hoping to recreate our success.

It was both thrilling to receive such attention and attain such great success. It was also deeply satisfying to have created a unique experience that helped people in a significant way. However, there was another side to this phase of my life.

The inner journey

My business partner and I were very different people, and we had very different skill sets and levels of entrepreneurial experience. For me, it was my first company, and for him, it was just one in a string of companies he had owned and operated. I threw myself into the operation of the business from the start, and I immediately felt out of place and overwhelmed with what I was doing. I felt very, very unqualified to be an entrepreneur.

I was learning new things on a daily basis, and I was implementing what I learned immediately after. Some aspects of the business I learned as a result of doing things the wrong way: I learned from my mistakes. It was 1999—the early days of the internet—so there wasn't as much information available then. It was a massive growth period for me, one that went on for the ten and a half years I ran the business with my partner.

The company was in a constant state of growth and expansion, and that meant the same for me. It was hugely transformative on a personal and professional level, but also incredibly frustrating and exhausting. I'm very grateful for the experience

because I learned so much about business and marketing, but it was indeed a trial by fire.

Besides, my business partner and I had very different values, and he made decisions based on his values that regularly conflicted with my sense of integrity. I found myself in a position where I allowed him to make decisions for the business that felt entirely out of alignment for me.

The shadow side

There was also a shadow side to this experience: my partner. My business partner wasn't a great person. I'm no psychiatrist, but he fits the profile of someone with narcissistic personality disorder. He was also a workaholic and demanded that I follow his example in working long and exhausting hours. He engaged in gaslighting, a tactic in which one person makes someone else question their reality, usually to gain control or power over them.

While I was busy at work co-creating and marketing this beautiful healing refuge for our guests, I also heard things like:

- *"You're so stupid. You're not even smart enough to be a secretary."*
- *"You're worthless."*
- *"You never do anything right. When anything goes wrong, you should just automatically apologize, because it's probably your fault, even if you think it's not."*

It was confusing because part of me knew that I was doing great work and getting great results in our business. The feedback I was getting from my business partner didn't correlate with the reality I was seeing. But because I heard things like this day in and day out, over the course of ten years, I started to lose touch with reality. I began to question what I was seeing. I

stopped trusting myself, and I began to believe the things I heard at a very deep level.

These statements, and many others like them, seeped into my subconscious mind and adversely affected my beliefs. They set me up with a mindset that would negatively affect my future business ventures and make it very, very difficult for me to build a successful business on my own. It's been over a decade since I left that partnership, and I've taken that long to undo the damage. I'm still working on my healing. This stuff went in deep.

The disconnect deepened

Eventually, I became so disconnected from myself that I had no idea which way was up, in terms of my internal compass. The gaslighting had me completely disoriented. So many things felt wrong, and I felt so lost that I didn't know how to get myself out of the mess I had created for myself.

Ten and a half years later, when I quit running the company, I was so lost and out of touch with myself that I didn't know what I wanted. All I knew was that I couldn't take it anymore. I no longer wanted to be running a business with my partner, even though I dearly loved the people who worked for us, and I felt terrible about abandoning them, which was how I saw it at the time.

A new beginning

Eventually, I left. In 2008 I moved out, and almost a year later, I quit the business. It was one of the hardest decisions I'd ever had to make. I had co-created the company from scratch, and I genuinely cared about the business and the people who worked there. But I knew it had to be done, for my own mental and emotional wellbeing.

Around the time I left my company in 2009, I met my husband. With his help, I started to realize I wasn't the stupid, useless person I believed myself to be. I also began to understand just how bad things had been for the past ten years of my life. I had lost all perspective on how I deserved to be treated by others.

After quitting my first company, I took an extended sabbatical, which ended up lasting almost a year and a half. I took time off to heal, rest, and recover. I also spent the time trying to figure out what I wanted to do next. I knew I had lots of skills, but I wasn't sure what to do with them.

Near the end of the sabbatical, we packed up everything and moved to London, where I trained as a coach and as an NLP (Neuro-Linguistic Programming) practitioner. I was so excited to run a business where I could help people once again, albeit in a very different way. I was very enthusiastic about my new skills, and I was confident that I was on the right path.

I started with a life coaching business, helping women to find their life purpose. It was tough, and I struggled to get clients, despite knowing what I needed to do to start a business. Out of all the other coaches I trained with, I was the only one who had a decade of practical business and online marketing experience. I knew what to do, and I was putting it into action, but for some reason, my company just wasn't working.

After several months of struggle, I heeded the advice of a business mentor. I settled into a social media marketing company, where I used the skills in online marketing that I learned in my very first company to help authors learn to use social media for marketing their books online. This business later evolved into helping women solopreneurs with social media. But it still wasn't easy.

The struggle

I was making enough money to support myself and to pay the bills, but it was a constant struggle. Building my business was *so damn hard*. There was no sense of ease and flow. It was all push, push, push to get minimal results. It was exhausting and disheartening.

If my first business was a lesson in practical business and marketing skills, my solopreneur adventures have been a lesson in business mindset. In Tribal Publishing and Socially Holistic, the names of my social media companies, I learned for the first time about the *other* kind of struggle that happens in business—the one that very few people discuss. (Tribal Publishing started out providing social media services and consulting for authors and only later evolved into what it is today: my own publishing company, which also provides publishing services to authors.)

In my new companies, I was no longer part of a large organization; I was a solopreneur, and my company was all about *me*. I didn't have the confidence to step into my greatness and shine brightly with my new business endeavors.

On the contrary: I shrank into the shadows, crippled by my smallness. It felt like I was taking one step forward and two steps backward with my marketing. I was trying to put myself out there, but *not too much*. I was playing it safe—safe inside my comfort zone.

For the first time in my life, I battled my inner mindset gremlins—lack of confidence and low self-esteem—as I struggled to build my social media business and get clients. New fears, blocks, and limiting beliefs reared their ugly heads daily. I believed I wasn't good enough, and that I wasn't worthy of having a successful business. It felt crippling.

And the worst part of it was that I had no idea what was going on. I just thought that I needed to take yet another online

marketing course (despite having ten years of experience in the area) or hire another coach or business mentor (despite already knowing what I needed to do). I believed those things would fix all my problems. I struggled, and I pushed, and I put in so much effort, but I didn't get much in terms of results.

A light in the darkness

I was entirely in the dark about what was going on: that my mindset didn't serve me one bit. It was full of fears and blocks and limiting beliefs that kept me stuck. I was also struggling with personal issues that weren't shifting no matter what therapies I tried.

A friend of mine eventually recommended that I train in a process that he was using with his clients: PSYCH-K®. This process helped me to quickly and easily change my subconscious beliefs. It was a simple process that helped me to easily communicate with my subconscious mind so I could change the beliefs that limited my self-esteem, my relationships, my business performance, and even my physical health. I used it to transform *every single aspect of my life.*

I started where everyone starts: with the Basic Workshop, and I used the process daily with myself. The results were so quick and precise that I attended the Advanced Integration Workshop, and later the Pro (which has since evolved into the Master Facilitation Workshop). Not wanting to miss a single workshop, I traveled to the US to attend the Health and Wellbeing Program, which completely transformed my physical health and wellness.

When I find something that works, I throw myself into it completely. After using this process regularly for over a year, I went back and did all the training *again.* This time, I was able to absorb the little details that made much more sense after more than a year of working with this process regularly. It deepened

my understanding of beliefs and how I worked with them, and it made me a much better facilitator. I was settling into my mindset work, both with myself and with clients.

Big life changes

This process was life-changing. It lifted me from a place of stuckness and struggle and transported me into a place of ease and flow. The more I used it, the easier things became.

My mindset dramatically shifted to a more positive, uplifting state. Tasks that I had previously procrastinated on suddenly became easy to complete. Working through my to-do list became easy, rather than a constant struggle. Reaching out to joint venture partners, something which used to terrify me, was instantly simple. Setting up Facebook ads to reach a larger audience, something I used to balk at, became easy. Being visible in my business felt natural, rather than terrifying.

I know this sounds too good to be true, but here's what was happening: I was no longer sabotaging my efforts. That alone made everything so much easier. So many of the things that used to hold me back became easy to take action on. And as a result of taking these actions, my business grew, and it was easier to get clients to sign up for my products and services. Things started to flow with ease.

This process was so hugely transformational for me and my business that I knew I had to start using it to help others. I added it to Socially Holistic, my social media company because so many of the women I worked with had inner struggles around their online marketing. They either believed they weren't tech-savvy, or else they were afraid of being visible online in a big way. Or both. I used to say that I helped people with social media from the inside and out. Not only did I teach them practical techniques and strategy, but I also helped them to release the blocks that kept them from

using this strategy so they could step up in a more significant way.

The more I worked with women on the inner side of online marketing, the more I realized that this mindset work was my favorite part of my business. It was the most fulfilling part of my work, and I decided it was time for me to transform my business once again. It was a big decision, but I was confident that I was on the right path.

Big business changes

I decided to let go of the technical aspect of Socially Holistic and revisit a brand I had built a few years back when I first trained as a coach: Ready to Bloom. I had always loved the name, and it perfectly fit the work I was doing: helping women solopreneurs transform their business mindset so their business could bloom. I wanted to help as many entrepreneurs to be successful in their businesses as I possibly could.

In 2016, I rebranded once again and let go of the Ready to Bloom brand. As much as I loved the name, I felt that it was time for me to stop hiding behind a business name and step up into my personal brand. I was the central part of my business and the work that I did, and it was time to make that apparent through my business name. I'm positive that it was my mindset work that led me to this point. It had once felt safe to hide behind a business brand, while now it felt limiting. It was time to step up and *just be me.*

Interestingly, this decision came just one month after I released the first edition of this book. Writing and publishing my first business mindset book was yet another significant step in terms of business visibility and claiming my spot as an expert in the field of business mindset. It was a big, scary step, and it triggered lots of hidden limiting beliefs for me to work on.

"Who are you to write a book about business mindset?" demanded my mind gremlins. But I did the mindset work, I released the fears and limiting beliefs, and the book went out. Since then, I've written and published another eight books and one workbook.

And I've continued to grow from there, not just as a writer but as an author-entrepreneur.

Heart-centered Energy Work®

In late April 2016, about the same time, I was rebranding my entire business, I received a message from my spirit guides via my business mentor, Lisa Wechtenhiser (http://lisamw.com/). Spirit guides are energetic beings that include angels, ascended masters, ancestors, elementals, and spirit animals or power animals. Essentially, they're spirits that have the ability and desire to help us and guide us in life.

Lisa calls herself the "trust whisperer," and she's been an essential part of my journey to stepping into my power and trusting my intuition. She's helped me to step up in a much bigger way. I come away from each session with her with lists of mindset work to do on my own. Lisa also calls herself "practically woo" because she channels your guides as she delivers practical business advice. This two-pronged approach to business is super powerful.

In this particular session, the guides chimed in to inform me that I was experiencing a significant upgrade, like a door opening. They told me that I was about to experience a shift in terms of what I did and how I helped people to transform their mindset. They urged me to make a list of which aspects of PSYCH-K® felt right to me, and which parts didn't.

They asked me to look at what I most resonated with, and what wasn't me. The guides suggested I explore how I currently blended these things, and to consider whether maybe there

was a new way to do my work. They said that it was time for me to find what that worked for me—something new.

The spirit guides told me that I needed to create my process. They asked me to put together a list of ingredients and to metaphorically put them into a mixing bowl and stir them up. They said that the process I would eventually use with clients would look very different.

They were right. I went away and made my lists, and I spent most of 2016 with the plan to create a new process. I intuitively knew that it would be something that I would receive as a kind of information download and not something that I would create rationally. And so I waited for it to happen.

And I waited.

It was a long process, and there was a bit of struggle, mainly because I simply didn't make the time and space for it to come through. But eventually, in late 2016, over the course of just five days, I channeled the new technique that I later used to help clients with their business mindset. It's called Heart-centered Energy Work®, and it helps to not only transform beliefs at the subconscious level but also to release any energy blocks at the same time.

It's quick and powerful, and it gets excellent results for both my clients and me. The critical point for me to make here is that I would never have been able to channel this profoundly transformative technique if I hadn't done the mindset work to get myself to a place where I believed I could do it. I believed in myself, and I knew I had the power to receive this information, but only because I had previously done the mindset work to reprogram my beliefs.

Author-entrepreneur

And then, in late 2018, I decided to quit my business mindset work to focus on my writing. This change felt like a risky move.

I worried that people wouldn't take me seriously. I stressed that people would think I was flaky—yet again. But I knew that I loved writing, and I wanted to focus my work on helping a wider audience. That would be much easier to do by writing books, rather than filling my calendar with one-to-one sessions.

I've been there

As you can see, I've come from a challenging place: one of extreme lack of self -belief and self-confidence. I know what it's like to feel frustrated not to have all the necessary pieces to have your business work. I know what it's like to focus on the practical side of the business and to ignore the mindset work completely. I know what it's like to struggle. And I've come out the other side.

That's why it was so vital for me to tell you my full story: so you could see how far I've come in just a few years. I ran my first business from 1999 to 2009 and started my coaching journey in 2011. It wasn't until mid-2013 that I started to focus on my mindset—that's less than three years before I released the first edition of this book.

That's not much time, considering how far I've come in terms of mindset. I went from being in a very, very dark place to release my smallness and stepping into my greatness. I let go of the mind crap that was holding me back, and I adopted new beliefs that served me better.

And then it all came together: my coaching training from back in 2011 has helped me to help my clients dig deep and to get clear on what's currently holding them back and what they want instead, so we can start transforming those beliefs quickly and effectively. My work with authors in my first social media business in 2012 has given me the tools and knowledge to help people through my books, such as this one. And my extensive mindset work, which I began in 2013, got me to the place where I believed in myself.

This process all sounds straightforward in retrospect because I can now look back on the past few years and see how it's all come together seamlessly. But there were some murky bits, which I hope that I clearly expressed when telling my story because I believe that it's essential to look at the shadow side of things. The deeper we dig, the more valuable the treasure we will find.

When I speak of treasure, I'm referring to two things: first, the core limiting beliefs that, once shifted, will unlock and transform all the other limiting beliefs that hover near the surface and are often easier to spot. One of my PSYCH-K® instructors called this "finding the diamond." We can work much more quickly when we're willing to dig deep within ourselves to get to the root of an issue.

The second part of the treasure is clarity. A lot of my work —first with one-to-one clients, now with my books—involves helping people get clarity on exactly what it is that they *do* want so that we can program that intention into their subconscious. Once you have a clear vision for your business, and once you believe that you're capable of achieving this vision, the easier it will be for you to take practical action to make it happen.

Now that I've shared my business journey with you and you can see the power of mindset work, we're ready to talk about the power of beliefs, the power of the subconscious mind, and the power of energy work. Because that's where we often get stuck, and that's where the real magic can happen, once we know how to do the work and get out of our way.

Take action today

Before we get into the next chapter, I'd like to encourage you to write down *your* story. Start wherever you want: you can begin with your first job in high school, or your lemonade stand as a child (I had an orange juice stand). Get into the details when

you relate your business journey: what were all the different iterations of your business? What did you do? How did you help people?

Most importantly, how did you *feel* at all the different stages of your entrepreneurial journey? Were you afraid people would find out you were a fraud? Were you afraid you weren't good enough? Did you always compare yourself to other entrepreneurs with a similar business model? What were your fears and beliefs about yourself and about your ability to run a successful business? What are your current fears and beliefs?

4

THE POWER OF MINDSET

"The passion for stretching yourself and sticking to it, even (or especially) when it's not going well, is the hallmark of the growth mindset. This is the mindset that allows people to thrive during some of the most challenging times in their lives."

— CAROL S. DWECK

Mindset is defined as the established collection of beliefs and attitudes held by a person, essentially, their unique way of thinking. It's like the framework of beliefs or the lens that we use to perceive our reality. The word was first used sometime between 1925 and 1930, but it has become popular in more recent years with Stanford psychology professor Dr. Carol S. Dweck's 2006 book *Mindset: The New Psychology of Success*.

Her book centers around the dichotomy of the fixed mindset versus the growth mindset. People that have a fixed mindset believe that their unique qualities are established, unchangeable traits. People that have a growth mindset believe

that their abilities can be developed through learning, practice, and work. If you're reading this book, you probably have a growth mindset. Most entrepreneurs do.

The beauty of having a growth mindset is that we believe that we can improve our lives. We believe that we can improve our intelligence and our skill set, which leads us to learn new things, to try new things, to embrace new challenges, to learn from feedback, and to practice resilience so we can persist when we experience setbacks.

The simple, yet compelling, belief that *we can improve* opens up a world of opportunities to us. And a part of that improvement is upgrading and transforming our belief system. In the same way that we can learn new skills, we can also acquire new beliefs. When you're looking at your business mindset and evaluating whether or not your own unique set of beliefs serves you, it's crucial to take into consideration *all* types of beliefs:

1. your conscious beliefs
2. your subconscious beliefs
3. your superconscious, or higher self

Mindset work is so much more than just positive thinking —having a positive outlook or positive expectations in life. The deep mindset work that I talk about involves digging deep into exploring what our current fears and beliefs are, and what beliefs we need to have instead to achieve our goals and create the business we want to have. It involves tapping into the wisdom of our higher self to see which beliefs are needed, reprogramming these beliefs at the subconscious level, and then taking action to integrate these beliefs into our mindset.

Our mindset is an integral part of our success. If you have any doubts as to the importance of mindset and beliefs, read up on the placebo effect, including the success of placebo pills and

also placebo surgeries. Ellen Langer's 1981 Harvard University study showed the impact of mindset on aging and appeared to reverse many of the symptoms of aging after just one week. Langer's later study on hotel housekeepers showed how our perception of how much exercise we get affects how our bodies look. The group of housekeepers who were told that their work burned calories and contributed to a healthy lifestyle showed a decrease in their weight, as well as a 10 percent drop in blood pressure.

If our minds are so powerful that we can transform our own health by changing our beliefs, imagine what we can do for our business. In the next chapters, I'm going to talk about exactly how we can do this. First, we're going to delve deeper into some specific aspects of mindset: the power of beliefs, the power of the subconscious mind, and the power of working with energy.

Take action today

Before we move on, take a few moments to think about or journal on your mindset. It's important to acknowledge all the things we've experienced that have contributed to our current state of mind. We've been working on our mindset for years— for better or for worse—even if we haven't been aware of it. Now, we're going to take that work to a deeper level, and undo some of the damage that we've suffered over the years.

Before you read this chapter, were you aware of the concept of a fixed mindset versus a growth mindset? Can you see which kind of person you are? Can you identify some times in your past when you've put this growth mindset into action through learning new things or improving on your skills? What things are you doing right now in your life to improve yourself and your abilities?

On the podcast

You can find the full list of podcast episodes here:
www.hollyworton.com/podcast

- 270 Holly Worton ~ Why Mindset Matters
- 209 Carmen Spagnola ~ How Nature Can Get You The Right Mindset For Business
- 181 Jo Casey + Holly ~ Is Mindset Important in Business, or Is It Just an Excuse to Avoid Action?
- 136 Holly Worton ~ Why You Can't Afford to Ignore Your Business Mindset
- 115 Holly Worton ~ How to Get the Right Mindset for Your Business

THE POWER OF BELIEFS

"Watch your thoughts, for they become words,
Watch your words, for they become actions,
Watch your actions, for they become habits,
Watch your habits, for they become your
character,
Watch your character, for it becomes your
destiny."

This quote has been misattributed to several people over the years, including Mahatma Gandhi, Ralph Waldo Emerson, Lao Tzu, Gautama Buddha, Bishop Beckwaith, and the father of Margaret Thatcher. The fact that it has been misattributed to so many different people shows just how powerful these words are, and what an impact they've made on a variety of very different cultures. In reality, it doesn't matter who first uttered these words (though if you're curious, according to Quote Investigator (http://quoteinvestigator.com/tag/frank-outlaw/), the earliest evidence of this quote dates from 1977, when it was published in a Texas newspaper that

attributed the words to Frank Outlaw, owner of the Bi-Lo supermarket chain).

Never heard of Frank Outlaw? That doesn't matter (although it probably does explain why people have tried to add weight to this quote by misattributing it to more famous people). What matters is that these words are valid: our thoughts and our beliefs create our reality.

Beliefs are the things that we hold to be true, whether or not they are. Beliefs are subjective. They represent an acceptance that someone or something—an idea or a concept—exists or is right, even without proof (for if we had evidence, then this acceptance would be knowledge, rather than belief). They may also indicate having trust, faith, or confidence in someone or something.

They are the foundation of our personality; they are the elements that we use to define ourselves as individuals. Different people hold different beliefs, and our unique beliefs are part of what makes us who we are. Our ability to step into our greatness and create the business and lifestyle of our dreams depends on our beliefs, which directly influence our behavior.

Beliefs come from every area and every stage of our lives: we form them based on our interactions with authority figures such as our parents, our teachers, our superiors at work. They come from our peers—friends, co-workers, family. We are continually forming beliefs based on our actions and our interactions with others. Unfortunately, however, many of our beliefs are not conscious, which is something that we'll examine in the next chapter.

If your mindset is fraught with limiting beliefs, you will struggle to build your business and create the lifestyle you want. On the other hand, if your mindset is supported by beliefs that lift you up, building your dream business will be much, much more manageable. That's why we must keep our

beliefs positive and focused on what we *do* want, and not what we *don't* want. Unfortunately, most of us tend to focus on the former.

Watch your thoughts, for they become words

We often express our limiting beliefs in our language. When our current mindset isn't serving us, and a friend asks us how our business is coming along, it can be easy to fall into a victim mentality and say things like:

- "I'm never going to make it. It's just too hard."
- "It's so hard to get clients. I don't know how anyone does it."
- "Building a business is easy for other people. I'm having such a hard time of it myself."

Have you ever heard words like these come out of your mouth? Or maybe you didn't say them. Perhaps they were just thoughts running through your head when you were silently complaining to yourself.

Or maybe you paid too much attention to your mind gremlins, who whispered things like:

- "You're not good enough. You'll never make a living with your business."
- "You're not smart enough to learn all the things you need to learn to market your business."
- "Be careful. If you get too big, people will find out you're a fraud."

Perhaps you found yourself at a business networking meeting, where someone asked you how business was going, and you replied that things were great—yet in the back of your

mind, you were thinking just how hopeless you felt. I can't begin to count the times in the early days of my business where people would ask me how things were going, and I would smile and reply enthusiastically. I didn't want to jinx myself by telling the truth, so I pretended everything was fabulous.

Spoiler alert: it wasn't.

These words of self-doubt, whether spoken or unspoken, make up our mindset. Remember: your mindset can support and enhance you and your business, or it can sabotage and undermine you and your business.

Watch your words, for they become actions

Our beliefs are directly related to our actions. If we have confidence in ourselves and if we have a mindset full of firm beliefs about our ability to create a successful business, then we're more likely to take the necessary actions to make that successful business become a reality. On the other hand, if our minds are fraught with limiting beliefs, we're more likely to procrastinate, hiding from the actions that will put us out there, make us visible, and get the clients we need to create our dream business.

A positive mindset will support you in stepping into your greatness. A limiting mindset will keep you stuck in your smallness. Either way, your beliefs influence your actions.

I've seen it so many times with clients: one struggled to create videos for her YouTube channel, which she knew was essential to the growth of her business. She insisted that she wasn't tech-savvy. She spent hours crafting careful scripts, which she would then run through a teleprompter to read as she recorded her videos. This process took hours, and it meant that she put off doing videos as much as possible. After just one session where we focused on changing beliefs around her video creation, she was able to create inspiring,

focused videos on YouTube by speaking spontaneously to the camera.

I had another client who also struggled with technology. The more she complained that she didn't know how to do tech things for her online business, the more she remained stuck. We worked on shifting her beliefs around technology, and she was able to work with her web designer to build a new website for her business quickly.

In my own experience, one thing that I've heard myself say more than once is that "I'm not good at play." I often take myself and my business too seriously, forgetting to allow space for fun, play, and joy. And of course, the more I repeat "I'm not good at play," the more truthful that statement becomes. It wasn't until I realized that play could take many forms—some of which I was already practicing—that I understood that I was a playful person and that I could add more play (and therefore more fun!) to my business.

Watch your actions, for they become habits

And, of course, the more you continue to take the same actions, the more they become ingrained. Eventually, they're transformed into habits. You continue to take (or avoid) the same actions, and this only serves to reinforce your neural pathways, keeping you stuck in the same place.

I used to have the bad habit of procrastinating on my emails. I'm talking about messages that I had to respond to personally—emails that I couldn't delegate to an assistant or someone else. I would let them pile up for days in my inbox, and just seeing them would stress me out (though to be fair, having more than twenty emails in my inbox at a time makes me anxious!). I finally started blocking out time in my calendar regularly, where I would force myself to only work on my inbox, and that helped me to get back on track.

Even worse was my track record for returning phone calls. I've since significantly improved in this respect, but for many years I would procrastinate on making phone calls. I'd have them on my list of things to do, but often it would take me *more than a month* to make the calls. I hated phone calls that much. Often, so much time had passed that I would just cross the call off my list because it was no longer relevant.

I used to be extremely organized and tidy. For the most part, I still am, mostly because I get anxious when things are disheveled or out of place. But sometimes, I get into the habit of accumulating a pile of paperwork on my desk—and then not doing anything about it for weeks at a time. Eventually, I'll sift through the papers and process everything, but in the meantime, it looks terrible, and it stresses me out to see it every day. The simple act of adding new papers to that pile soon becomes a habit.

Most unwanted habits can be eliminated by simply changing our behavior. Sometimes that's easy to do, such as in the examples above, but sometimes it's harder. When we notice that we're struggling to shift an unwanted habit, it's time to stop and take a look at our mindset.

What are we afraid of? What are our beliefs about these tasks? I once worked with a client who was behind in doing her tax return. She had boxes and boxes of receipts and paperwork, but she couldn't bear the thought of going through everything. She knew it wouldn't take more than a couple of days to sort through, but she was afraid of what she'd find. And she was scared of how much tax she would owe. Eventually, we did some mindset shifts that made it easier for her to get through the stack of papers, and it was a massive relief. She owed much less than she feared, and she was able to set up more supportive habits for the following tax year.

The easiest way to release these stubborn habits is to change your beliefs. Figure out what you're currently doing

that doesn't serve you, and what you'd rather have instead. Then, do the mindset work to make the changes you need to make to have a mindset full of beliefs that support you. You'll learn more about how to do that in later chapters.

Watch your habits, for they become your character

If your habits are made up of the actions that you've taken so many times that they've become almost involuntary, then your character is made up of your unique collection of habits, among other things. The saying goes that actions speak louder than words, and this is especially true in this case. You may think that your mindset is in good shape, but if your actions prove otherwise, then you need to take a look at how your beliefs are influencing your character. I'm sure you've heard the saying: don't pay attention to what people say; pay attention to what they *do*. What do *your* habits say about *you*?

I once knew an entrepreneur who believed himself to be a charismatic and creative leader in his company, but his actions proved him to be an insufferable tyrant. Employee morale was terrible, despite his enthusiastic pep talks. He regularly and consistently micromanaged people (or bullied his managers into doing it for him), and he erupted into tantrums whenever things didn't go his way. These weren't random situations, but consistent and recurring events that eventually showed most people that this was simply the way he was—despite his belief to the contrary.

On the other end of the spectrum, I used to be painfully quiet and shy. This shyness went way back to my school years, where I dreaded being called upon by teachers to answer a question. I would go out of my way to avoid eye contact, even when I knew the answer. I just didn't want to be the center of attention. This quietness continued throughout elementary school into high school, university, and even grad school. I was

good at taking tests and writing papers, but I dreaded any kind of verbal participation in class.

The more I avoided it, the worse it got. It wasn't until I joined Toastmasters in 2011—a public speaking club—that not only did I get over my fear of speaking, but I began to enjoy it. It didn't take long before I started to seek out speaking opportunities.

You may believe yourself to be a budding online entrepreneur destined for success, but if you're struggling to send out emails to your list or write a new blog post, you might want to consider what's going on. You can most definitely transform yourself into a successful online business owner, but you're probably going to have to do some work on your beliefs first.

Watch your character, for it becomes your destiny

Destiny often refers to fate or a predetermined and unavoidable course of events. I don't believe in fate or destiny, so for our purposes, let's look at it as the power that determines a sequence of events: let's explore your "destiny" as a successful entrepreneur or business owner. Can you see how your character, which is made up of your thoughts (beliefs), words, actions, and habits, directly influences your ability to create a successful business (or not)?

When you do the mindset work to overcome the fears, blocks, and limiting beliefs that are keeping you stuck, it makes it so much easier to take action—which is what eventually gets you results in your business. At the same time that you release limiting beliefs, it's essential to reprogram your mindset with new beliefs that support you in your business vision. When your business beliefs are aligned with your business goals, action-taking is easy and effortless.

When I used to work with clients, we would dig deep to

identify which beliefs were holding them back, and then we changed those beliefs, replacing them with positive, supportive beliefs. We would do work at both the subconscious and energetic levels to create profound, lasting change. At the end of each session, we would create an action plan that involved taking real-life, practical business action toward their goals. When I work with myself, I follow the same process: identify current beliefs, transform them, take action.

In changing your beliefs, you change your destiny. It's that simple.

Take action today

Can you think of examples of how your thoughts—perhaps in the form of mind gremlins—became spoken words that weren't very nice? And can you see how those words influenced your actions, which may have later become habits? Can you see how each of these steps may have affected your character? And finally, can you think of examples of how your words, actions, habits, and character have negatively impacted your business?

On the podcast

You can find the full list of podcast episodes here: www.hollyworton.com/podcast

- 306 Holly Worton ~ How To Create New Habits That Last
- 197 Holly Worton ~ Step into Your Greatness by Upgrading Your Business Beliefs
- 192 Holly Worton ~ Get the Mindset You Need to Make a Big Impact

THE POWER OF THE SUBCONSCIOUS MIND

"We never stop to consider that our beliefs are only a relative truth that's always going to be distorted by all the knowledge we have stored in our memory."

— MIGUEL ÁNGEL RUIZ

L et's talk a little bit about the subconscious, also known in the field of psychoanalysis as the unconscious mind. French psychologist Pierre Janet coined the term "subconscious," which is the anglicized version of the French word *subconscient*. The 18th-century German Romantic philosopher Friedrich Schelling coined the term "unconscious mind," which was later introduced into English by poet and essayist Samuel Taylor Coleridge. It was eventually popularized by Austrian psychoanalyst Sigmund Freud, who saw the mind as being comprised of three levels:

- the conscious (10 percent of total brain function)
- the subconscious (50–60 percent)
- the unconscious (30–40 percent)

Modern-day representations of the conscious and the subconscious/unconscious minds will put the breakdown at 10–12 percent for the conscious mind and 88–90 percent for the subconscious/unconscious mind. For this book, all we need to know is that roughly 90% of total brain function does *not* take place in the conscious mind. This concept is fundamental.

You may have seen the use of an iceberg as a metaphor for the subconscious mind: just the tip of it is visible above the water, with the vast majority of the iceberg being invisible, submerged. The visible section represents your conscious mind, with the submerged part representing your subconscious mind because it is unseen, operating in the background. It's like a foundation for the conscious mind, which metaphorically sits on the surface.

Let's dig a bit deeper into the two. We'll also explore a concept known as the superconscious mind, which you may or may not be familiar with.

The conscious mind

This is the part of your mind that you're aware of throughout the day. You use it to envision what you want for your company, and you use it to set your business and life goals, to make decisions, and to plan your day. It's where logic and intellect reside, as well as your short term memory. Critical thinking skills are a part of the conscious mind, which you use to think abstractly and judge results. A big part of running your business happens in the conscious mind.

The conscious mind is time-bound and has an awareness of the past and the future. It is also said to have a minimal processing capacity: it can only focus on one to three events at a time. Again, the conscious mind makes up only about 10 percent of your total brain function.

The subconscious mind

The subconscious mind is the other 90 percent. It's responsible for all of your involuntary physical functions, such as breathing and walking. It monitors the operation of your entire body: it keeps your motor functions operating, it keeps your heart going, it makes your digestive system work, and it carries out all of the functions of your body. Take breathing. For example, you do not think about when to inhale and exhale; your subconscious mind handles that for you.

In addition to handling our essential body functions, the subconscious also handles the parts of the mind that we are not fully aware of, but which influence our actions, feelings, and emotions. It is responsible for our habits and patterns. Because the subconscious handles our long-term memory, it's in charge of storing all of our life experiences. It holds our past events, our attitudes, our beliefs, our values.

The subconscious mind is said to think literally. When you are communicating with it (you'll learn how to do that in a later chapter), you need to be crystal clear on what exactly it is that you want. The subconscious is in some ways like a small child: it takes everything you say to the letter. If you are familiar with the law of attraction, you may be aware of this concept: you need to be very specific about what you want so you can communicate the right message to the subconscious mind.

The subconscious mind is also timeless: it exists in the now. Because it only deals in the present time, it has no sense of past or future. If you work with affirmations or belief statements, they need to be in the present tense.

They also need to be positive statements, as the subconscious does not process negative commands. If you try to program a belief such as "I don't get myself into debt," the subconscious will ignore the "don't" and instead will hear "I get

myself into debt." Think about it this way: if you're in London and you want to visit Covent Garden, you won't get good results by walking up to someone and saying "Please don't give me directions to Buckingham Palace." You'd want to specifically ask for directions on how to get to Covent Garden because that's where you want to go. Focus on what you do want, not on what you don't want.

Our subconscious is also responsible for our self-sabotage. It has all this information based on our life experiences stored in its long term memory, and it's in charge of self-preservation. This means that—based on the beliefs it holds—it can some-times make somewhat illogical decisions or lead us to take irra-tional action in its effort to keep us safe and secure.

While this can be incredibly frustrating, it's important to remember that our subconscious is merely trying to help. If a person "accidentally" misses a deadline to apply for a speaking engagement, that might simply have been their subconscious trying to help them avoid public humiliation. Like when they stood up in front of the class in fifth grade to give a presentation and then tripped and fell, causing the entire class to burst out in laughter.

The subconscious mind is a powerhouse: it does so much, and it does it automatically, working in the background. It is not something that we usually control. However, it is something that we *can* control: instead of falling victim to the often unhelpful guidance of our subconscious, which may be oper-ating on old programs, we have ways of programming new beliefs into the subconscious.

When I talk about "deep mindset work," this is what I mean: reprogramming new beliefs into our subconscious. This process is how I work with myself and with other people to transform beliefs and mindset. Unfortunately, most people are unfamiliar with these types of techniques, and therefore this is

something that they do not do on a day to day basis. Most of us function with the subconscious running its programs automatically, even when they no longer serve us.

The superconscious mind

Some spiritual belief systems acknowledge a third part of the mind, known as the superconscious or higher self. You may know this by another term, such as the authentic self, the divine self, the higher mind, universal consciousness, or the soul. If you don't believe in this concept, that's fine, and you can move right along to the next section. I need to address this, but you don't have to believe in it yourself. You'll still get the results from working with your subconscious mind.

The superconscious mind, or higher self, is the core of who you are as an individual. It knows your path to success, your life purpose, your life passion. It knows where you've come from and where you're going. It's in charge of delivering wise guidance to you in the form of your intuition or gut feeling. If you believe in a higher power, you may see it as being your connection with the Divine, Source, Spirit, God, Goddess, or whatever you call this spiritual power.

The superconscious can also be accessed to get wisdom regarding our mindset and the beliefs that we need to have to achieve our goals—more on that in a bit.

Take action today

What are your thoughts about all this? Take a few minutes to think about—or to journal on—your current relationship with your conscious, subconscious, and superconscious minds. Are you truly in touch with each aspect of yourself? Do you feel better connected to one part of your mind than to the others?

Do you believe in the concept of the superconscious mind? If so, what do you call it?

On the podcast

You can find the full list of podcast episodes here: www.hollyworton.com/podcast

- 272 Holly Worton ~ Mindset: Why It Isn't About Positive Thinking

THE POWER OF WORKING WITH ENERGY

"The energy system feeds the subconscious, and the conscious mind. If you eliminate a problem from the subconscious, without dealing with it in the energy system, it's likely to come back."

— MICHELLE LOWBRIDGE, WEALTHOLOGY: THE SCIENCE OF SMASHING MONEY BLOCKS

The process I first trained in back in 2013, PSYCH-K®, is very cerebral and logical, and it focuses very much on subconscious beliefs and creating belief statements or goal statements. Energy does come into play in some of the different ways of changing beliefs, but the vast majority of the work centers around belief statements, which we'll discuss later on in this book. I can be a very logical person, so I found this process to be really suitable for my needs. But when I read Michelle Lowbridge's book *Wealthology*, the quote above triggered me in a big way.

I was so enamored of PSYCH-K® because it had changed my life in so many ways, that I resisted accepting the above

statement. How could energy work be even more powerful than subconscious work? Subconscious work was incredibly powerful! I didn't understand at the time.

It took me a while to let that concept sink in.

The reality is that energy work *is* very powerful, and I didn't fully understand that until I channeled my Heart-centered Energy Work® process and started working with it, both with myself and with clients. The reality of my experience is that releasing blocks in our energy field while at the same time reprogramming our subconscious beliefs gets me the quickest and most potent results. Some clients see changes the very next day after a session, or even in a matter of hours. Why is this?

Life force energy

It all has to do with life force energy, known by many different terms around the world: ki, qi, prana, baraka, and nwyfre are just some of its names. Energy flows through all living matter. While traditional healers around the world have known this for centuries, modern science has also confirmed it.

Energy healing works by tapping into our energy field and working directly with the mental, physical, emotional, and spiritual aspects of ourselves. It addresses any discomfort caused by a disturbance in the energy flow, be that a blockage or an excess of energy in a specific area.

There are many energy healing processes and techniques, some of which you may have heard of: reiki, qigong, acupuncture, reflexology, Pranic Healing, Matrix Energetics, Emotional Freedom Techniques®, Quantum Touch®, and ThetaHealing® are just a few examples.

And, as Carolyn C. Ross, MD, MPH states in her *Psychology Today* article on energy healing: "Energy healing or energy medicine is something that's used in conventional medicine

when we do MRI's [*sic*] or other types of scanning and many other procedures. We just don't call it that."

Unfortunately, there's a lack of quality scientific studies examining the benefits of energy healing, so if you're the kind of person who needs everything to be backed up by science, you'll be disappointed here. This is one of those things that you either believe in. . .or don't. The choice is yours!

Take action today

Have you ever tried a type of energy healing? How did it make you feel? Did it get you the results that you were seeking? Are you open to this type of work? If not, that's okay, too—you can get fantastic results from using processes and techniques that feel more logical. There are so many techniques out there that can help you change your beliefs and your mindset, and it's merely a matter of finding what works for *you*.

On the podcast

You can find the full list of podcast episodes here:
www.hollyworton.com/podcast

- 283 Joanna Hennon + Holly ~ Remember, It's Not Just About Energy: Balancing the Inner and Outer Work

HOW TO COMMUNICATE WITH YOUR SUBCONSCIOUS MIND

"Our thoughts are mainly controlled by our subconscious, which is largely formed before the age of 6, and you cannot change the subconscious mind by just thinking about it. That's why the power of positive thinking will not work for most people. The subconscious mind is like a tape player. Until you change the tape, it will not change."

— BRUCE LIPTON

There are many ways to communicate with the subconscious mind, but hypnosis is probably the best-known method for obtaining information from it. While hypnosis can be incredibly powerful and life-changing, there are faster, simpler, and easier methods. (But again—use the technique that works for *you*.)

In my experience, the quickest and easiest way to communicate with the subconscious mind is through muscle testing. This method is an easy way for us to connect directly with our subconscious or with other people's subconscious minds (in the case of working with a client). The theory behind muscle

testing is this: when the mind holds a stressful thought or belief, a conflict is created in the brain, and this produces a weak response in the body. You may have seen people do muscle testing by pressing down on another person's outstretched arm.

I've learned many different ways of doing this over the years, and I used it a lot when I worked with PSYCH-K®. The trick is to find the best method for *you* when doing self muscle testing, and the best process for your *partner/client* when you're working with others. In this chapter, I provide a quick explanation of how to use muscle testing both with yourself and with someone else, but you may find it easiest to refer to my video on the topic, which is available on my YouTube channel: www.hollyworton.com/youtube.

Muscle testing with a partner

For muscle testing with a partner, the arm is generally used. The partner or client will hold their arm out to the front or the side, and the other person will press down on the arm as the first person resists the pressure. The instructions below assume that you will be the person doing the testing with someone else, as I go into self muscle testing in the following section.

Step by step

1. Your partner will stand facing you, slightly off-center, so that you are looking over each other's shoulders. You can also do this sitting down if you prefer (just ensure that the feet are flat on the ground and the legs are not crossed at the knees or ankles). The only requirement is that both you *and* your partner be sitting, or standing. It's important that the person who is doing the testing is not hovering over the person who is being tested. You need to be at roughly the same level. Also

consider your heights: if one person is a lot taller than the other, it might be best if you both sat down.

2. Ask your partner to extend one arm (whichever they prefer) out to the side, parallel to the floor. Ask them to keep it stretched out.

3. Ask them to keep their chin parallel to the floor, eyes open, and facing down.

4. After getting permission from your partner, you will put your hand on their shoulder and on their wrist, and you will say "Be strong" or "resist" before gently pressing down on their wrist as they resist the pressure. Be sure to check with them to see if the pressure is at a good level. If you need to adjust, just play around until you find the best strength of pressure *for your partner*.

5. Test for a strong/weak response by checking true/false statements (things which your partner absolutely knows to be true). Ask them to say out loud: "My name is [Theirname]." This should test strong, meaning that their arm finds it easy to resist the pressure and remain parallel to the floor. Next, ask them to say out loud: "My name is [Nottheirname]." This should test weak, meaning that their arm will find it difficult to resist the pressure, and will be pushed downwards.

Be sure to use a name that doesn't correspond to anyone your partner actually knows, because this could generate a false positive. Try unusual names, or names that obviously don't correspond to your partner, such as names of celebrities.

This may also get your partner laughing at the names you come up with, which will help them to relax into the process.

You can also use other statements that you and your partner absolutely know to be true/false, such as "The sun rises in the east" and "The sun rises in the west." "The sky is blue" (assuming you don't live in an area that suffers from extreme smog) and "The sky is orange."

6. Switch places and ask your partner to go through steps 1-5 with you, so you can experience muscle testing for yourself.

7. Now, you are ready to move onto the belief statements in this book, testing to see whether or not you (and your partner) hold the listed beliefs at the subconscious level.

There are other techniques for muscle testing with a partner. You can hold your arm out in front of you; you can hold your arm bent at your side in an L shape, and test only the forearm, or you can use a leg to muscle test. If the person is lying down, you can also have them raise their arm straight in the air, or bent at their side in an L shape. Search online for other examples of muscle testing with a partner if the examples above don't work easily, or if they have an injury.

Self muscle testing

This is a bit tricky to explain in writing, which is why I've created a quick video that demonstrates each of these methods of self muscle testing. You can find that on my YouTube channel: www.hollyworton.com/youtube. Many people find it tricky to get clear on which of these techniques is easiest for them.

My best advice is to play around with them all until you find the best one for you (you may have noticed a theme here: finding what works for you as an individual is important in every step of this process).

Finger circle

With one hand you make a circle with your finger and thumb, and with the other hand you insert one finger from the other hand into the circle and push the inside finger against the circle. You can use any finger, along with your thumb, to make the circle, and you can use any finger on your other hand to break the circle. Play around with it to see how much pressure it takes to force that circle to break or to hold, and then test it with the true and false questions.

Test: "My name is [Yourname]" and "My name is [Notyourname]" (or any of the examples above). When you try this method, it is also important to figure out which fingers are best for you to use during testing. When you make the circle, try your index finger, your middle finger, your ring finger, your pinkie; try all of your different fingers on both hands. The way I personally do it is to use my middle finger to make the circle with my thumb on my right hand, and I test with the index finger on my left hand (I'm left handed; for you it might be the other way around).

This is one of the most common ways that I use to do muscle testing on my own because I find it to be the easiest method for me. . .but again, this is all about finding the best method for *you*, which is why I've included six other methods for you to try.

Fingers as arms

You can also use a method called fingers as arms (or maybe it's just me who calls it that), in which you place your hand flat on your leg, thigh or table, and raise up one finger to be the "arm" that you then press down on with a finger from your other hand.

Test: "My name is [Yourname]" and "My name is [Notyourname]" (or any of the examples above). As with the previous method, it is very important to figure out which fingers are best for you to use during testing. Try your index finger, your middle finger, your ring finger, your pinkie as the arm; try all of your different fingers on both hands. I personally find this method to be a bit difficult, but it works for some people, so give it a try.

Double circles

This is very similar to the first technique, with the finger circle, except that in this method, you make two interlocking circles, which you then pull apart to test.

Test: "My name is [Yourname]" and "My name is [Notyourname]" (or any of the examples above). As with the previous methods, it is very important to figure out which fingers are best for you to use during testing. You can make the circles with different fingers.

Sticky/smooth

In this method take, for example, your index finger and your thumb and rub them together as you test: "My name is [Yourname]," "My name is [Notyourname]." When you get the strong response it is very, very smooth when you are rubbing your fingers together and when you get the weak response it kind of

"sticks" in the sense that it feels harder to rub your fingers together. Again, try different combinations of fingers to see what works for you: index and thumb, middle finger and thumb, ring finger and thumb, little finger and thumb.

This is another method that I find difficult because it's so subtle, but I've seen it work for people who struggle with some of the other methods.

Scissors

In this method, you hold two fingers out, as if they were scissors, and then you press on them with two fingers from the other hand. You could even do your own version of the Vulcan greeting from Star Trek and make a larger scissors with two fingers on each side (that feels pretty awkward to me, but it's worth a try). Play around with different combinations of fingers and hands to see what's best for you. This is another one that I find a bit tricky, but give it a try and see if you like it.

Stand and sway

This is another common technique. In stand and sway, you stand up, relax your knees, close your eyes and check for true and false. Say "My name is [Yourname]" and allow your body to be pulled either forward, backward, left, right, counter-clockwise, clockwise or not at all. And then give the weak or the false test: "My name is [Notyourname]," and then see how your body moves.

When I try this method, my strong is forward and my weak is backward. But it could be that your strong is left, and your weak is right. Your strong could be clockwise, your weak could be counter-clockwise; it is different for every person.

I find this method to be very easy, but also kind of a pain, as it involves standing up, which isn't always convenient when I'm

doing a lot of work with myself. Also, it's pretty conspicuous, making it a bit awkward to use in public (unless you don't mind people staring and wondering what exactly you're doing).

Pendulum

Another method that I use is a pendulum, and I've been using it for years. This is a method that a lot of people find to be easy to use, even those who struggle with the finger methods.

Test: "My name is [Yourname]" and "My name is [Notyourname]" (or any of the examples above). You can also say "Show me a yes" and "Show me a no." It might sway back and forth or side to side or clockwise or counter-clockwise. The response is different for every person. When I use the pendulum, the strong/yes response is forward and backward and the weak/no is from side to side, but (as in all of these methods) it may be different for you.

Top mistakes

Here's a quick list of the top mistakes I see people making when using muscle testing. Use this list to troubleshoot whenever you encounter difficulties. Some people pick it up easily; others require time and practice to get it right.

Improper position

No matter what technique you are using, you want to be sitting or standing with your chin parallel to the floor, and your eyes looking down. Your feet should be flat on the ground, and your legs should not be crossed at either the knees or the ankles. You

should also be as relaxed as possible, while still sitting or standing up straight.

No clear response

Whenever you start muscle testing, whether it's self muscle testing, or working with someone else, you always want to start out with the true/false test: "My name is [Yourname]", "My name is [Notyourname]". If you struggle to get a clear response with that, move onto other statements that you absolutely know to be true/false, such as "The sun rises in the east" and "The sun rises in the west". Also try "The sky is blue" (assuming you don't live in an area that suffers from extreme smog) and "The sky is orange."

Come up with other statements that you know to be true and false: "I am a human" and "I am a cat", for example. If you can make yourself laugh by coming up with silly statements to test, that will help you relax, which will then make the process easier.

Not finding the right method

Another mistake that many people make is not finding the best method for them. Be sure to take the time to find what technique works for you. If you're struggling with self muscle testing, be sure you've exhausted all possibilities before giving up. Finally, get help if needed.

Weak/weak response

One thing that can "go wrong" is when you get a weak/weak response. You might get a weak to your name and also a weak to the name that is not yours. In this situation, you might be dehydrated or you might need a snack. Have a drink of water,

or have a bite of food if you think you're hungry, and test again. Keep drinking water (within reason—don't go overboard with it) until you test strong to the true statement and weak to the false statement.

Strong/strong response

Sometimes you get a strong/strong response, which is when you get a strong to [Yourname] and also a strong to [Notyourname]. When this happens, you might simply need to calm down, relax, and get centered. You might be experiencing stress (particularly if you've been really struggling with muscle testing). If you've been experiencing problems with muscle testing for several minutes, take some time to rest and do something else before returning to your testing.

Take action today

Go to www.hollyworton.com/youtube and watch my YouTube video that demonstrates each of these methods of self muscle testing, and test each one of them for yourself. Find which one works best for you.

If you have a friend or family member who is willing to experiment with you, try to muscle test with them. Invite them to try it with you so that you can see what it feels like.

On the podcast

You can find the full list of podcast episodes here: www.hollyworton.com/podcast

- 96 How To Use Muscle Testing In Your Business, with Holly Worton

HOW TO USE THE BELIEF STATEMENTS

"All action results from thought, so it is thoughts that matter."

— SAI BABA

This list of over one thousand belief statements is divided into categories, based on the most common topics that have come up in my work with myself and my sessions with clients:

1. Action and Goals
2. Change and Growth
3. Clients and Boundaries
4. Confidence and Self Trust
5. Creativity
6. Leadership and Outsourcing
7. Learning
8. Lifestyle
9. Marketing and Sales
10. Money
11. Personal Power

12. Strategy, Clarity and Vision
13. Success and Opportunities
14. Value and Self-Worth
15. Visibility

You may find it easier to work with these lists by printing them out. When I was working with belief statements with clients on a regular basis, I always had a printed version of these lists at hand. I put them into a binder to make it easy to flip through them. You can download a printable version of this list here: http://hollyworton.com/bbb, or you can get the companion workbook, which has the full list of belief statements in it.

Test your beliefs

You can use muscle testing, which you learned in the previous chapter, to see which of these beliefs you already hold at the subconscious level. This can be extremely useful, because often we think (at the conscious level) that we hold a particular belief, but in reality our subconscious is not on board with that belief. This means that we're stuck in a state of conflict, which keeps us stuck in business.

Play around with the statements, and muscle test to see which beliefs you actually hold at the subconscious level and which ones you'll need to work on.

Find the priority

Another way to use the list is to find which category of beliefs is the most important one to work on, and which are the priority belief statements to work on in each category. You can do this by using muscle testing to tap into your superconscious mind, or your higher self. That's the part of you that knows what's in

your best interest and highest good, and when you set the intention, you can ask your higher self which areas are the highest priority for you to work on.

You may be wondering: how do you know whether you're asking the subconscious or the superconscious when you're doing muscle testing? It's simple: just set the intention before doing the testing.

You can do this is by testing the following statement: *"The highest priority statement is in the category of Action & Goals."*

If that tests weak, then move onto the next category, and test: *"The highest priority statement is in the category of Change & Growth."*

Keep going until you find the right category. Once you've found the highest priority category, then ask which is the highest priority statement (for this example, I'm assuming a list of 35 statements): *"The highest priority statement is between numbers 1 and 18."*

If it tests strong, then narrow it down to the exact number. (*"The highest priority statement is between numbers 1 and 9." "Between 1 and 5." "Between 1 and 3." "The highest priority statement is number 1." "Number 2."*)

If it tests weak, test: *"The highest priority statement is between numbers 19 and 35."* Then, narrow down as in the above example.

Once you determine the highest priority statement, test to see if it's strong or weak. If weak, either work on changing the belief yourself (if you've done training in how to do so), or seek help from a trained professional who can work with you.

Change your beliefs

If you've done training in a technique that works at the deeper levels, you can work with yourself to reprogram your beliefs. If you're new to changing beliefs at these deeper levels, you might

want to either work with someone else or train in a technique that you feel drawn to. Find the best process or method for you: Heart-centered Energy Work®, PSYCH-K®, ThetaHealing®, EFT (Emotional Freedom Technique), NLP (Neuro-Linguistic Programming), TAT (Tapas Acupressure Technique), hypnotherapy, or something else.

What I like about both PSYCH-K® and Heart-centered Energy Work® is that they are fast-acting, easy to use, forward-focused (they focus on what you *do* want, not what you *don't* want), and they work with very specific beliefs and intentions. These are my preferred processes to use.

Build a clear intention

You can also use the belief statements to help you build a clear intention of what you *do* want. You can make a list of all the belief statements that you want to program into your subconscious mind, and then group them into themes for when you do your mindset work. The belief statements, as you've seen, are already grouped into broader categories. Still, you may want to create several sub-categories for your use when putting together the belief statements to create intentions.

For example, one of the categories is Money. You might want to create a specific intention around your ability to build a successful business that brings in a certain amount of money each year. You might create another intention around all the things that this money allows you to do in your life. If you've had trouble holding onto money in the past, you might want to create another specific intention around your ability to be responsible with money.

The way I use Heart-centered Energy Work® is to build up a clear vision and intention of what I want, and then I work on programming that intention into the subconscious, while at the same time releasing any energy blocks. You can also do this

using other mindset techniques and processes. If you're feeling stuck when creating a clear vision of what you want for your business, read through the belief statements, and select the most appropriate ones to build up your vision for your business.

Here's one example of an intention that's based around money and the things that money can do for you:

I am a well-known, successful life coach. My calendar is filled with clients I love working with, and I have a waitlist filled with people who are excited to work with me. I'm making a great living from my business, and am consistently bringing in at least [specify amount] each month. My steady income allows me to travel with my family, and to take the kids on exciting trips all over the world. My successful business also allows me to take time off in the summer and over the holidays. I feel happy, fulfilled, and proud of myself.

Do you see what I mean? Each one of those could be an individual belief statement, but strung all together in one paragraph, they've now become the basis of a clear intention that you can use in your mindset work. The process/technique that you choose to work with will drive whether you use individual belief statements or specific intentions.

Or you can spend some time journaling to get a clear vision of exactly what you want in your business: what your ideal workday looks like, how often you go on holiday, how much revenue you're bringing in, etc.

Take action today

As I mentioned earlier, it's essential to take practical actions to reinforce the changes you've made in your mindset. It's a way of telling your brain that you're serious about making changes, and it's the only way to build a successful business. You can't just sit back and do the mindset work and wait for a miracle; you need to take action to make things happen.

I often explain that my process of business building is like going up a spiral staircase: you take one step with your left foot (mindset work) and another step with your right foot (practical action), and step by step, you build your business. I compare it to a spiral staircase because of this: as you reach new levels in your business, you'll be greeted with new mindset work to do: different versions of limiting beliefs that you couldn't see before because you were at the lower levels.

It's like when you're hiking, and you climb a hill or a mountain, and you get to the top and can see all around. You have a much broader vision of the landscape, and you can see things that you couldn't see down below. It's the same with mindset work. You've got to be the one to take the steps to get to the top of the hill or the next level of the staircase.

HOW TO CHANGE AT THE DEEPER
LEVELS

"If we could get your subconscious mind to agree with your conscious mind about being happy, that's when your positive thoughts work."

— BRUCE LIPTON

Affirmations don't work. At least, not as well as some people would lead you to believe. This is a divisive statement, and I know that many people don't feel the same as I do about affirmations. If I've just triggered a knee jerk reaction in you, please read on so you can understand my logic here. I think they're a good start: if you had never heard about doing mindset work at the deeper levels, then affirmations would be better than nothing. They get you focused on what you *do* want—rather than what you *don't* want—and eventually, after many repetitions, they'll sink into your subconscious.

You may be tempted to repeat some of these belief statements over and over as affirmations, and affirmations can indeed help change your beliefs at the *conscious* level. But it

takes ages of repetition to get them to get into your subconscious. And if your subconscious mind isn't on board, then it will be running its programs in the background and will end up effectively sabotaging your conscious efforts. Plus, by repeating affirmations, you won't be taking into account any energy blocks you may have.

Here's my problem with affirmations: they take so much time. You've got to repeat them every day. And you've got to *remember* to repeat them every day. Yes, they get you focused on your goals and intentions, but they're just not very useful in terms of the ratio of time-to-result. Thankfully, there's an easier way of doing it, and that's working at the subconscious and energetic levels. Hopefully, you've understood by now that it's faster and easier to work that way. I like easy, especially when so many of the other things I do in life are quite challenging.

Over the years, many of my clients have asked me to muscle test some of their favorite affirmations for them. They wanted to see if their subconscious mind believed them or not. Inevitably, they test weak, which means that their subconscious mind does not accept the affirmations that they've been dutifully repeating for weeks on end. People are always surprised when this happens, but I've seen it so many times with so many clients that it's led me to believe that affirmations are a complete waste of time. (Again, if they work for you, then keep at it—but if they work for you, then why are you reading this book?)

Now, I know that "affirmations don't work" is a strong statement, because I do believe that they can be useful at the *conscious* level. But why waste your time repeating an affirmation over and over for hundreds—or thousands—of times, when you can change a belief at the deeper levels, more quickly and easily, in just a few minutes? Yes, you read that right. It's possible to completely reprogram your beliefs at the deeper levels in only a few minutes.

Work alone or with someone else

You may choose to do the work alone, with yourself, if you've trained in a technique that works to change beliefs. You may also want to work with someone else. For me, the perfect solution is to work both with myself *and* with other professionals.

I do regular work with myself using Heart-centered Energy Work®, and I also work with other professionals using other techniques. I find this the most effective way to work. There are many things that I can see that need to be worked on, and I do the work on them. But there are other things that I find it difficult to see because I need a fresh, different perspective on them, and that's where another professional can come in and help me to pick apart the issue that I need to work on.

Another practitioner or facilitator can help me to see a new perspective on a situation, and they can also help me to dig deeper into an issue and push me to work on things that I may not have considered on my own. Again, each person needs to find their own best way of working on their business beliefs, but in my experience, I've gotten great results with this combination approach.

Work at the deeper levels

I'm of the school of thought that only *you* know what's best for you (this should be clear by this point in the book). I recognize that there is no one technique or solution for everyone, and there's a whole range of other tools out there that work at the deeper levels. Find the best method for you:

- Heart-centered Energy Work®
- PSYCH-K®
- ThetaHealing®
- Emotional Freedom Techniques® (EFT or tapping)

- NLP (Neuro-Linguistic Programming)
- TAT (Tapas Acupressure Technique)
- Ask & Receive
- hypnotherapy
- ...or something else

Search online for the different options and speak with friends to see what's worked for them. But keep in mind that what's worked for someone else may or may not work for you. Sometimes your journey will involve trial and error until you find what's best for you. I tried so many things over the years before I found what worked best for me, and eventually, that evolved into me channeling my process, Heart-centered Energy Work®.

My guides once described HEW® as a spiritual process in an envelope of magic, whereas other techniques I've worked with have very much been a mental process. They were the right thing for me at that time, and as I've grown, I'm now working with something that I find even more effective—for me. Again, do what works for *you*.

Subconscious + energy

I clearly understand that the power of HEW® is that it works by simultaneously reprogramming beliefs at the subconscious level and releasing energy blocks by transforming the energy centers in our bodies. Working at these two deep levels at the same time, in the same process is what helps both my clients and me to get fast, long-lasting results. But again, you need to use the technique that gets you results, and that feels right for you.

Take action today

Have you heard of any of the methods and techniques that I mentioned above? What are some others that you're aware of that I haven't discussed? Have you tried any of them? Did you like them? Did they get you the results that you wanted? If you've never heard of any of these techniques, go online and read up on them. See which one (or ones) you're most drawn to, and give it a try.

For example, I recently read a book that discussed TRE® (Tension & Trauma Releasing Exercises) as a way of releasing trauma from where it's been stored in the body. My gut instantly said, "YES!" and I went online and found a provider in my area. In just over a week, I was at her home having my first session.

Go with what feels right or what catches your attention. There's a reason you're drawn to it.

GET CLEAR ON WHAT YOU WANT

"When you know what you want, and want it bad enough, you will find a way to get it."

— JIM ROHN

B efore we get into the different categories of beliefs and the belief statements themselves, you need to know what you want. Are you 100% clear on the vision you have for your business and life? How do you want to step into your greatness and become a leader in your field? What do you want to experience in your business and life?

Back in 2015, I did a podcast episode on How to Get Clear on Your Big Business Vision (find it here: www.hollyworton.com/111/), which includes a guided meditation and a worksheet that walks you through each stage of this process to help you get clear on exactly what you want for your business. On that page, you can also find links to download both the meditation and also a pdf with these questions so that you can write them out.

I highly recommend that you print out this list or write the

answers down in your journal (or get the workbook edition of this book, which has plenty of room to write down your answers). This is essential information that will help you to determine what you need to believe to make your dream a reality.

Visual

Let's imagine that you've fully stepped into your greatness and that you're living your big vision for your business and life.

- What does stepping into your greatness mean to you?
- What does that look like?
- What do you see yourself doing?
- How do you see yourself starting your day? What time do you get up? Do you set an alarm, or do you wake up naturally?
- What does your morning ritual look like? How long does it last?
- What do you eat/drink in the morning?
- What do you do once your morning routine is over?
- What time do you start working?
- Do you work from home, or do you leave home to work? What does your office or workspace look like?
- What do you work on? Your own creative projects? Do you do work for clients or with clients?
- If you're working with clients, what does this look like? Envision yourself with one of these ideal clients.
- Are you writing, creating art, or content for your business? Envision yourself doing whatever it is that

you'll be doing once you've achieved this goal of
your ideal business.

- Take a look at your bank account. Either look at
your bank statement, or access your account on your
computer. Now that you've got your ideal business,
how much money is in your checking/current
account? And how much do you have in savings?
How much do you have in investments and in your
pension/retirement fund?
- What does the rest of your day look like?
- What do you eat/drink throughout the day?
- What else do you do throughout the afternoon?
- What time do you wrap up your work or creative
activities?
- What does your lifestyle look like? What else are
you doing in your life, when you're not working
directly on your business? What do you see yourself
doing?
- What do you see yourself doing for exercise/fitness?
What time of the day do you exercise?
- Where do you see yourself living? What country are
you in? What city, town, or village? Is it an urban
environment, or is it rural?
- What does your home look like?
- What does your evening or nighttime routine look
like? How long does it last?
- Is there anything else you need to look at to give you
a clear vision of what things look like now you are
living the life of your dreams? Take a few seconds to
look at that.
- As you reflect on your day, you see how your ideal
day is different from your current lifestyle. What are
some other things that are different?

Auditory

- Once you've fully stepped into your greatness, what will you be saying to yourself? It could be: "I'm proud of myself," "I can't believe I did this," "I'm so happy that I made it," or something else.
- What will you hear other people saying about you? It could be: "She's amazing," "Wow, I can't believe what she's done with her business," or something else.
- What are your clients saying about you?
- What else do you hear in your life, now that you've fully stepped into your greatness? What's going on in the background as you live your day? Do you hear children? Pets? Birds? Music? Other people?
- Is your home in a quiet area, or is it bustling and active? What about your office or workplace?

Kinesthetic

- How do you feel when you wake up in the morning?
- How do you feel throughout the day? What are your energy levels like? What emotions are you feeling?
- How do you feel in the evening as you're getting ready for bed?
- Now that you've fully stepped into your greatness, how do you feel? Are you feeling free? Satisfied? Proud of yourself? Excited about the future? Write down *all the things* you feel.
- What are you grateful for in your ideal lifestyle?

Dial it up

Often, our beliefs limit our vision for ourselves. Read through your answers and mark any details where you're playing small or hesitating to dream big. Dial up the intensity and the bigness of your vision: how can you make it better, more exciting, or more satisfying? No one else has to see this but you, so don't be afraid to make your dream bigger, better, and bolder.

As you dial up the intensity of this vision, pay attention to any fears or limiting beliefs that you have, and write those down. What fears do you have about living this ideal lifestyle? What will people think of you? Will you lose family or friends with this lifestyle change? What will they say about you? Do you believe you're worthy of having this dream? Are you deserving of living this life of your dreams? Write down all the "yes, buts".

Repeat

You can repeat this visualization or this process as many times as you like. You may want to repeat it every quarter, so you can get clarity on how your vision has grown and changed over the previous months. As we grow, our vision for our business changes and we need to understand precisely how our ideal business vision changes over time so we can adjust our goals, strategy, and business plan accordingly.

I've been talking a lot lately about stepping into your greatness, and when we're not in a good place, it can be hard to tap into our greatness and see what it is. So give yourself permission to dream big and to repeat this process regularly, so you can gradually step up your vision of what you want for your business and your life. Each time, you'll expand your vision of what's possible for your business and life.

Action plan

- What are the top three actions you could take this week to bring you closer to stepping into your greatness?
- Who do you need to be to take these actions?
- What do you need to believe about yourself to take these actions easily?
- What might stop you from taking these actions? What would you rather have instead? How would you rather feel about your action plan? What do you need to do/experience instead? What do you need to believe about yourself and your ability to complete this action plan?

Business beliefs

- Who do you need to be to step into your greatness fully? Who do you need to be to achieve your big business vision?
- What do you need to believe about yourself to step into your greatness fully?
- What's stopping you from stepping into your greatness? What would you rather have instead? What do you need to do/experience instead?

Wrap it up

Is there anything else you need to add to the vision? Are there any specific goals that you need to add that you want to achieve as part of your vision for stepping into your greatness? Get it all

out and into words that you can see. That will make it easier for you to identify specific beliefs in the lists that follow.

Take action today

If you haven't already, answer the questions that I've posed for you in this chapter. They'll help you dig up fears and limiting beliefs for you to work on. Then decide when you want to revisit these questions and put it in the calendar, so you remember to do it.

On the podcast

You can find the full list of podcast episodes here:
www.hollyworton.com/podcast

- 195 Holly Worton ~ How to Stay Grounded + Strong in Your Vision
- 111 Holly Worton ~ How to Get Clear on Your Big Business Vision

CATEGORIES OF BELIEFS

"The truth is that there is no actual stress or anxiety in the world; it's your thoughts that create these false beliefs. You can't package stress, touch it, or see it. There are only people engaged in stressful thinking."

— WAYNE DYER

I've divided up these belief statements into fifteen categories, which I consider to be essential facets of business mindset that I've regularly worked on with clients over the years. You may find that you have more work to do in some areas, and you may find that you have very little work to do in other areas. In any case, it's worth muscle testing your beliefs to see what the highest priorities are to work on, as your higher self will know what your conscious mind may not be aware of. Remember, depending on what type of work you do to transform your business beliefs, you may want to choose specific beliefs to program into your subconscious, or you might use some of the beliefs as part of a broader intention or goal.

If you previously downloaded the first edition of this book, you may remember that there were over six hundred belief statements included. Now there are more than one thousand. I was delighted to go through my old journals from the last couple of years and discover hundreds of belief statements that I had created and worked on programming into my subconscious.

The fascinating part of reviewing my journal and selecting specific belief statements to add to this book was that I was able to see how big I was thinking last year when I was doing this work, and also how many of the things that I worked on have come to pass. It was a blatant reminder of how powerful this work is, and that when we transform beliefs at the deeper levels, it makes it much, much easier for us to achieve our goals. Which leads me to the first category.

Action and Goals

As I've said before, one of the most significant benefits of doing mindset work is that it makes it easier for you to take the right actions in your business. If you know that taking action is an issue for you, either because you suspect you've been taking the wrong actions or because you've simply been paralyzed with inaction, you might benefit from doing some work around this area.

This is a very, very important part of business mindset work because if you don't take practical action in your business, you're not going to get too far. You'll probably stay stuck where you are. All the mindset work in the world isn't going to grow your business if you don't take practical action.

There have been times in my business when I've been an action taker. And there have been times when I've procrastinated, and I've avoided doing things that I knew would take my

business forward. Usually, this was due to fears and limiting beliefs.

What beliefs do you have about yourself? Are you an action taker? Are you a go-getter? Are you good at getting things done? Or are you lazy? Are you a procrastinator?

Think about what types of actions you need to take to step into your greatness and achieve your big vision for your business and life. Think about what specific goals you need to set. What fears and limiting beliefs come up for you as you think about doing these things? Write them all down in your journal.

Change and Growth

You may need to change and grow in leaps and bounds if you want to step into your greatness and do the work you're here to do. And yet change can be scary: often we have an intense fear of the unknown. We know what things are like where we currently are, but we don't know what they'll be like after we change.

It can be challenging to trust that change is good, even when it brings unexpected challenges and learning opportunities. And even when we know that we're ready and willing for change, sometimes we fear that the changes won't occur as quickly as we want them to. Growth is another thing that we can resist: on the one hand, we may welcome it, but at the same time, we may fear leaving others behind if we grow too much.

I've made a lot of changes to my business over the past few years. I've changed the type of people that I work with and how I work with them. I've changed my business name many times, eventually settling on using my name. At each of these stages, I was afraid of making these seemingly significant changes. What would people think of me? Would they think I was unprofessional because I was pivoting in my business once more?

Think about how you need to change so you can step into your greatness and achieve your big vision for your business and life. Look at how you need to grow. What fears and limiting beliefs come up for you? Write everything down in your journal.

Clients and Boundaries

Clients and customers are at the core of our business, whether we provide services or sell products. When we're first starting, it can be tempting to take on any client who comes our way, but we eventually learn that business works best when we only accept people who are our ideal clients. Getting clarity on exactly who our ideal clients are can take time, and trusting that we can attract a steady stream of ideal clients can be even more challenging. Sometimes we have issues around believing that our ideal clients will pay the prices that we want to ask for our products and services.

Boundaries are another issue many business owners experience when they're first starting, as they grow, and as their business changes. It can be scary to set healthy boundaries if we fear that our clients will react angrily. We may even fear losing clients if we uphold our boundaries, such as telling a client they will have to forfeit their last session in a package because they didn't show up and didn't cancel in advance.

And now it's time for an embarrassing personal story. On the rare occasion that I take on one-to-one clients, I now see people exclusively online, but back when I was seeing clients at a local therapy room, I once had a VIP day client show up late for her appointment. Not just a few minutes late, but *three hours late* for a six-hour VIP day. I kid you not.

Now, my standard late policy is to wait for 15 minutes and then message the person and move on with my day. But rather than honoring my late policy, I sat there for *three hours* as she

phoned and texted and updated to let me know she was almost there. Almost. She'd be there soon!

I'm genuinely embarrassed to admit this now, but not only did I wait for three hours, I *didn't enforce my policy that she would forfeit that time.* So she finally arrived, we did half of the VIP day, and then I arranged for her to return the following day for the other half. I mentioned that I would have to re-book the therapy room, and she did pay me for the cost of that, but I didn't ask to be paid for the cost of my time waiting—the three hours that I sat there alone in the therapy room.

Would you like to guess what happened the following day? She was an hour late! I'm not joking.

These days, I understand precisely why this happened: she was seriously self-sabotaging. I know what was going on behind the scenes. And I take full responsibility for my role in the situation: the reality is that I enabled her to do this. The two of us co-created that situation together. And it was all thanks to a lack of boundaries on my part. I felt terrible at the time, but I said nothing.

Setting and reinforcing boundaries has been a massive challenge for me over the years. It's been one of my big life lessons, and there have been times when it's been tough for me to uphold the boundaries that I've set. Since this incident, I've done loads of mindset work around boundaries with clients (and other people!), and I don't have an issue with late clients anymore. To be fair, seeing clients online means that it's much easier for them to show up on time since they don't have to travel to see me, but I do uphold my fifteen-minute time limit for lateness.

Think about who your ideal clients are and what you need to believe so you can attract a steady stream of ideal clients. Look at what you need to believe about your ability to have a thriving business with a calendar full of ideal clients—and maybe even a waiting list. Look at your boundaries for working

with clients. What would you do in a situation where a client is late or doesn't show up at all? Write everything down in your journal.

Confidence & Self Trust

Confidence is one of the most significant issues that I've had to work on with myself, and it's no surprise that I tend to attract clients who need to work on this as well. My confidence was a mess after my first business (and, let's be honest, it was never great to begin with), and I was so out of touch with myself due to the gaslighting that I didn't trust myself at all. I didn't even know which way was up.

I found it hard to make decisions, and I would often second-guess myself after making them. Was I right? Should I have done something else? Was there another option that I wasn't even considering?

I once invested what at the time was a significant sum of money for me in a business mentoring program. A friend of mine had gone through the same program a year or two prior and had gotten great results from working with this business mentor. I didn't resonate with the mentor, but I wanted the results. I kept going back and forth. I spoke with my friend a couple of times on the phone, then with one of the people on the mentor's team. Finally, I discussed it with my husband. Yes, no. Yes, no.

My gut *knew* that it was not the right program for me, but my head tried to rationalize it. If it worked for my friend, then, of course, it would work for me! Right? Wrong. It was a terrible investment. I never did resonate with the business mentor, so her advice was hard for me to follow, and the content of the program was very introductory because it had been designed for very new business owners. There wasn't much of a community around the program (which I had been hoping for). The

whole experience was a flop—all because I didn't trust myself to make the right decision.

Do you need to be more confident in yourself and your abilities? Do you want to be sure of yourself when speaking and writing? Would you like to feel confident when expressing yourself and your message online? Where else do you need confidence in your business? Do you need to trust yourself better?

Think about what you need to believe so you can have the confidence to step into your greatness and the trust that you can achieve your big vision for your business and life. Think about what you need to believe to be confident and to trust yourself. Write this all down in your journal.

Creativity

I've always been a very creative person, so I took naturally to blogging and creating videos and recording podcast episodes. I really love creating content, and I find book writing really easy, unlike many people. In some of the entrepreneurial profiling tools available—such as Roger Hamilton's Wealth Dynamics— I'm a Creator.

I know that's not the case for many online business owners. Some people just don't feel creative. They don't trust their creative abilities. They struggle to create the online content they need to help them market their business. They're afraid of doing YouTube videos, Facebook Live videos, writing blog posts, releasing a podcast, writing email newsletters, and all the other things we do as online entrepreneurs.

Some people get bogged down in the details: they heavily script their videos or podcast episodes, which can take hours (and then looks and sounds awkward when they read the script because most entrepreneurs are not also actors). They spend weeks researching the equipment they need to record a video

or a podcast, rather than just picking something and getting started. They avoid writing a simple blog post because they don't feel like they're an expert on the topic.

What do you need to believe about your ability to write blog posts? About your ability to write a book? What do you need to believe so you can easily record inspiring videos? To create a podcast that gets tens of thousands of downloads? What do you need to believe about your ability to be more creative in your business?

Think about how you can tap into your creativity as you step into your greatness and achieve your big vision for your business and life. Think about what you need to believe about yourself and your ability to be creative. Write this all down in your journal.

Leadership and Outsourcing

Because my first business had over 150 employees in three countries at any given time during the high season, I had ample experience in both hiring and managing people when I started my coaching business. But most solopreneurs and online business owners don't have this experience. Even those who do come from a management background have often managed people in an environment where they were working to someone else's rules, which isn't the same as creating your own rules and boundaries for hiring and managing people in your own company.

Even though I co-owned and co-operated a successful company for over ten years, my business partner was so overbearing and so disrespectful that I didn't see myself as a leader at all. I felt small and unimportant. I didn't value my role in the company.

Do you see yourself as a leader? Do you want to be recognized as a thought leader? Do you feel strong and grounded

enough to step up as a thought leader? Do you feel ready to inspire people on a greater scale? Are you ready, willing, and able to hire and manage people as part of your business team? What do you need to believe about yourself to become a leader?

Think about what you need to believe so you can step into your role as a thought leader and achieve your big vision for your business and life. Think about what you need to believe about your ability to outsource tasks that aren't within your zone of genius. Write it all down in your journal.

Learning

I always did well in school, and learning has always been easy for me. That's why I've been surprised to see so many clients who have had to clear traumatic memories from childhood around learning. So many people were laughed at by teachers or told they just weren't smart. Those experiences continued to affect them and their ability to learn throughout the rest of their lives—up until they got help to shift their beliefs.

A friend of mine once told me the story of an elementary school teacher who disliked him, for no apparent reason. He was generally well behaved and did decently in school. But this one teacher was continually yelling at him and berating him. Many years later, his brother ran into this teacher, and they started talking. She asked about my friend, and his brother told her that my friend was a successful psychiatrist. The teacher was speechless. Based on her own beliefs about my friend, she had thought he wouldn't amount to anything. And yet he had gotten through medical school and had built a successful career!

Can you see how this type of treatment from a teacher or authority figure can affect you? Luckily, my friend was able to do well in life and complete medical school, but if he had taken

on his teacher's beliefs, he could have ended up as a failure in school, working a job that he disliked because he didn't believe he was capable of more.

What about you? Is learning easy for you? Are you easily able to teach yourself all the things you know about running an online business? When you meet an obstacle, can you quickly do an online search and find the solution? Or do you stay stuck where you are? What do you need to believe about yourself for learning to be easier?

Think about what you need to learn so you can step into your greatness and achieve your big vision for your business and life. Think about what you need to believe about your ability to learn these things. Write this all down in your journal.

Lifestyle

Work/life balance is something I struggled with in my first company, and I resolved to get better at it in my subsequent business ventures. I've had to re-learn how to set boundaries with myself and how to give myself permission to take time off and make the space to relax and recover. I know I'm not the only one, as I've had more than one client session where we've worked to release fears and blocks around the client's ability to manage a successful business and a happy home life.

And even though I'm able to design my own life as I want, I struggle with guilt from time to time. Some part of me still thinks I need to work a traditional work week from Monday to Friday, even though I regularly allow myself to be flexible with my workdays. I sometimes take Thursdays off to go on a walk, or Fridays to write my books. Right now, I'm working on this chapter during a Thursday–Friday workcation weekend, instead of doing it on the actual Saturday–Sunday weekend like I usually do. Part of me is delighted with the progress I'm

making on this book, but there's another part that thinks I should be in my office answering emails.

By doing the deep mindset work to transform our beliefs, it makes it possible to live the lifestyle we want. That's what has allowed me to be sitting in a hotel writing this chapter on a Friday afternoon. If I hadn't done the mindset work, I wouldn't have gotten this far. If I want, I can do further work on my guilt and limiting beliefs so that there are no icky feelings about scheduling a writing retreat during the week. And I probably will.

What does your ideal lifestyle look like? Be sure you plan your business accordingly. If you want plenty of freedom and space to do what you want, you may want to focus more on passive income than on one-to-one client services. Group services are kind of a happy medium between the two. Explore what your business needs to look like so it can support the lifestyle of your dreams, and look at what you need to believe about yourself to make it happen.

Get clear on the lifestyle that you want to accompany your business as you step into your greatness. Think about what you need to believe to make this a reality. Write it all down in your journal.

Marketing and Sales

Marketing and sales are practical business actions that we all need to take to grow our business. This was also my area of expertise within my first business. Still, once I became a solo-preneur, I had so many limiting beliefs around marketing and sales that I was very ineffective in my marketing and sales efforts. I had much work to do to change my beliefs about my ability to market my products and services before I could take the actions I needed to take in that area.

When you're the face of your company, it can be terrifying

to market your business: it's all about *you*. You can't hide behind your company, and you can't hide behind a team of other employees. Fears of being called out as a fraud are common, as are fears of negative comments and bad reviews. The reality is that some people will love you, and some people won't, and that's okay. But when our fears and limiting beliefs stop us from engaging in marketing and sales, it makes it pretty much impossible to run a business.

Maybe you come from a business background; maybe you don't. Perhaps you're new to business. Either way, what beliefs do you have about your ability to market your business, both online and offline? What beliefs do you have about your ability to have productive sales conversations with potential clients?

Think about what types of actions you need to take to step into your greatness and market your business. Think about what you would like your sales conversations to be like, and what you need to believe about yourself to make it happen. Write this all down in your journal.

Money

Money beliefs are a big part of business beliefs, and I always recommend that people who know they have money issues read Denise Duffield-Thomas's book *Get Rich, Lucky Bitch*. Denise is a money mindset expert, and she's excellent at helping people uncover their money blocks. Money mindset is her specific area of expertise—her zone of genius.

This is another area that I had big problems with. Despite having run a successful multiple seven-figure company for over a decade, I developed many limiting beliefs based on how that first business was run, especially in terms of cash flow and finances. I have much guilt around decisions that my business partner made that I disagreed with (yet still went along with). And while I've done much work in this area, I'm

still unraveling limiting beliefs that I acquired during those ten years.

If you're not making the money you want to make in your business, make this area a priority. There are over 100 money beliefs in this book that will support a healthy money mindset, so this is a great place to get started.

Think about what you need to believe to make the money you want to make in your business. Think about who you need to be to make it happen. Write it all down in your journal.

Personal Power

This is another big area for me, and I've almost tripled the number of belief statements in this category. I felt very, very powerless during my first business, despite the fact that I was one of two co-founders and a leader in the company. I've done much work in the past few years to help me to step into my power and embrace my greatness. As I went through last year's journals, I noticed a big focus on my mindset work in this category.

What is personal power? I felt so powerless for so many years that when I first came across this category in a training manual, I didn't understand the concept. It was so foreign to me. Personal power can be defined as the ability to take charge of your own life and to change its direction. It's made up of your self-confidence, self-esteem, self-love, self-acceptance, and self-trust. It's an attitude of inner strength, courage, determination, and groundedness that helps us to stand our ground and speak our truth. It's the internal quality that allows us to stand up and express our unique selves and speak up about what we believe to be true.

Many people need to work on the belief that it's safe and appropriate for them to step into their power. The word "power" can have a lot of negative connotations to it, especially

when power is abused, and is not used to help people. But if you intend to step into your greatness and become a leader in your field, you need to feel strong and grounded in your personal power.

When entrepreneurs are disconnected from their personal power, they fail to stand out in the crowd. They water down their message in an attempt to appeal to the masses and keep from rocking the boat with their real opinions. Rather than shining bright with their message, they whisper and hide in a shadowy corner of the business world. They're not vibrantly colored; they're beige.

Think about what you need to believe so you can step into your power and your greatness. Look at what stepping into your personal power means to you. What does it look like? Write this all down in your journal.

Strategy, Clarity and Vision

There have been many times in my business when I felt like I was floating along without a strategy. I knew things needed to change, but I didn't have a clear vision of how I wanted to pivot my business into something new and different. These murky in-between times have often been frustrating for me, as I feel like I'm struggling down a muddy trail with no clear end in sight. Not surprisingly, I've done loads of podcast episodes on this topic.

If you're still unclear on your business strategy and what you want for your company, revisit the last chapter and do the work to get clear on what you want. Maybe you're new to the business world and don't have a clear vision of what you want your business to look like and how you want to get there. Even if you're working with a practical business coach, it can be extremely helpful to get your mindset to help you execute your strategy more quickly and easily.

Think about what you want for your business and life. What's your big vision? How are you going to achieve that? Who do you need to be to realize your big business vision? What kind of person do you need to be? What do you need to believe about yourself?

Think about the specific goals you need to set for yourself so you can achieve your big business strategy. What beliefs might get in the way? What fears do you have about embarking on this path? Write this all down in your journal.

Success and Opportunities

While many people have dreams of being a successful entrepreneur, many of them are also afraid of success. How will their life change? Will they make more money than their partner and thus risk losing the relationship? What if their friends abandon them? What if family members ask them for money and personal loans? How will they deal with this change?

Fear of success is a real thing, and it often stems from a fear of the unknown: how will things change in your life when you become a huge success? Will you be happy with those changes? Or will unexpected changes occur that might make your life more difficult?

Similar fears can block our ability to recognize opportunities when they arise. I remember the first time I was approached for a public speaking opportunity. I had left my first business not long before, and I was still living in Buenos Aires. I was asked to speak about entrepreneurship to a group of American university students who were visiting from an MBA program.

I immediately said yes to the opportunity. But as soon as I hung up the phone, I started to regret it. I felt a tightness in my stomach; my body contracted in fear. I considered phoning the

person back and telling them I couldn't make it after all—that I had forgotten about a prior commitment on that date. I went back and forth in my mind about whether to do it or not, and eventually, I went ahead with it. It was a rewarding opportunity that I had almost missed out on because of my fears. This was back in 2009, before I ever signed up for Toastmasters, and before I knew anything about business mindset or business beliefs.

It was very much a situation where I felt the fear, and I forced myself to do it anyway. It ended well, with me being invited back to speak to another university a few months later. But it would have been much less painful if I had just done the mindset work to feel better about it.

Today, I would have a very different reaction to such an invitation. I recently spoke on the main stage at She Podcasts Live, the first podcasting conference for women podcasters. I gave a talk with my friend Amanda Cook from Wellpreneur on how to turn your podcast into a bestselling book, and I loved being up on the big stage with a room full of people listening to me. It was such a great experience that we hired a photographer to shoot the entire presentation because both of us knew that we wanted more opportunities like that in the future.

Think about what opportunities you've ignored or turned down in the past due to fears or limiting beliefs. Were you ever approached for a speaking engagement that you turned down due to fear? Did anyone ever invite you to be a guest on their podcast or write a guest post for their blog, yet you balked because you were afraid of showing up for a new audience? Have you ever been approached to do a joint venture with another entrepreneur, but you hesitated and lost the opportunity?

Get clear on what success looks like for you, and what types of actions you need to take to achieve success in your business and life. Think about what opportunities you would like to

attract into your business, and what opportunities you would like to pursue actively. What do you need to believe to make this happen? What do you need to change regarding your current beliefs about yourself? Write this all down in your journal.

Value and Self-Worth

Do you truly value your knowledge, skills, and experience? Do you appreciate your uniqueness? Do your rates and prices for your products and services reflect this?

While prices can be inflated in the online business world, I often see entrepreneurs err on the side of pricing too low rather than pricing too high. This low pricing often reflects their limiting beliefs that diminish their perspective on the real value of what they're offering.

When low self-confidence and low self-esteem are issues for an entrepreneur, low self-worth often comes into play as well. When we don't believe in ourselves, and when we're not confident in what we have to offer the world, it's hard to value our products and services. It's one thing to intentionally set lower prices so we can cater to a particular audience, but it's another issue entirely to undervalue ourselves.

Think about your professional, entrepreneurial, and life experiences that relate do your current business. Reflect on all the training, coursework, business coaching, and mentoring you've received over the years. Make a list of your skills. Read through the testimonials you've received from clients, and consider their perspective of how great you are and why.

These things all add value: they add up to make you the multi-layered entrepreneur that you are today. Your unique combination of education, professional experience, and life experience makes you different from anyone else on the market, and that adds value. Your unique personality and way

of working with people mean that you'll be a perfect fit for many people, and the more you tap into these qualities, the easier it will be for you to connect with these ideal customers or clients.

Also, look at the shadow side of this: where do you feel that you're not good enough? Do you feel bad about yourself because you don't have a university degree in your field of expertise? Or maybe you do have a degree, but not an advanced degree like a masters or a Ph.D., and you use this to support your beliefs that you're not good enough?

I've done loads of training in coaching and other healing and transformative processes and techniques, but I don't have a degree in psychology. I honestly believe that these alternative methods of working with beliefs and mindset are much more potent than anything I ever gained from a session with a psychologist. And yet, there's a part of my mind that says I'm not qualified to write a book like this because I don't have a degree. Thankfully, there's another part of my brain that acknowledges all the training that I've done and all the years of working with clients, and it's that part that's allowed me to sit down and write this book—and then to update it for this second edition.

Maybe you've got decades of corporate experience in your field, but less than a year of working independently as an entrepreneur. And something about being a new business owner (rather than a well established one) makes you feel inadequate. What are your limiting beliefs? Write all of this down in your journal and get clear on your unique value and self-worth. Also look at the fears and beliefs that get in the way of you truly believing in your worth.

Visibility

Visibility is a vital part of business mindset. You can be the best coach/mentor/healer/therapist/whatever in your field, but if no one has ever heard of you, you're not going to get clients. No matter how skilled and gifted you are, people need to know who you are so they can buy your products or sign up for your services.

And yet so many things can get in the way of us stepping up and getting out there and marketing our products and services. The first edition of this title was my very first book, and while I was excited to get it out there and release it into the world, I was also insecure about publishing my first book. I did a *very* soft launch: I mentioned it on my podcast, my YouTube channel, in my email newsletter, and on social media. But I didn't hire a book PR expert, nor did I invest in advertising to get *new* readers from outside my community.

I was terrified of bad reviews, and I was afraid that people would say I was a fraud for writing about mindset when I don't have a degree in psychology. There was probably a whole barrelful of other fears that kept me from really pushing this book out there to new readers and getting it known in a big way, but these are the biggest ones that come to mind.

Since then, I've received a couple of one-star reviews for my first walking book, *Alone on the South Downs Way*, and while they did hurt to read, it wasn't too traumatic, and I've moved on. They certainly won't stop me from releasing any future books.

In 2019, I published an entirely different type of book, about the stories of trees, titled *If Trees Could Talk: Life Lessons from the Wisdom of the Woods*. For the first time, I hired a fantastic publicist who got me on national television in the UK. From there, I was approached by BBC Radio Scotland, talk radio in Ireland, and a UK national newspaper. I was suddenly visible in a huge way.

Was it easy? It wasn't too bad. I spent most of the train journey into London on the day of my television appearance on getting clear on how I wanted to come across, and what I needed to believe so I could make that happen. Thankfully, the train wasn't full, and I was able to do the mindset work right then and there to transform my beliefs. Afterward, I did the same on the journey home: I had had a fantastic time, and I wanted to receive more publicity opportunities like that in the future. I identified the beliefs I needed to make that happen, and I changed them on the train.

I've worked with clients who were too afraid to do YouTube videos, write a blog post, or even set up a simple website for their business. I've had other clients who manage to do all those things, but then they don't promote them online. It's like they're creating secret videos and blog posts that they don't want anyone ever to see. I once had a client who got triggered by my questions during a session, and exclaimed, "I don't care if anyone reads my blog posts! I don't! I just want to put them out there." That wasn't the truth, but limiting beliefs can lead us to say all kinds of illogical things.

Think about what types of actions you need to take to show up in the world in a big way with your business. How do you need to market your products and services in a more significant way? How can you show up and *shine* as an entrepreneur?

Make a list of big name entrepreneurs that you admire. What things do they do? How do they do things differently? What can you do to be more like them?

And when you think about doing these things, what fears pop up for you? What beliefs come up? Do you think: "Yes, but she's thinner/prettier/smarter/whatever"? What are the "yes, buts" that come up for you? Write this all down in your journal.

Take Action Today

Go through this entire chapter and answer the questions. Spend some time really digging into your limiting beliefs for each of these categories. And then do it again on a regular basis. Remember the spiral staircase: as we ascend the stairs, we reach new levels where we can see limiting beliefs that we weren't able to access before.

ACTION AND GOALS

1. I easily achieve my business goals.

2. I have the drive to conquer obstacles and achieve my goals.

3. I have the self-discipline to focus on my most important tasks each day.

4. I am extremely motivated and focused in working on my business.

5. It's easy for me to focus on high-priority tasks to help my business grow.

6. I am disciplined and goal oriented.

7. I always feel motivated to get things done in my business.

8. I transform my reality to align with my goals.

9. I am focused, driven, and decisive.

10. I get things done quickly and easily and with plenty of time to relax.

11. I am clear, organized, and focused.

12. I am inspired to take action, and I do!

13. It's easy for me to take action to make my business a reality.

14. I am organized and consistent in my project management.

15. It's easy and effortless for me to identify my top priorities and take action on them.

16. I am organized with my time and I follow through with things.

17. I trust myself to take the necessary action to create a successful business.

18. I easily develop my great ideas through action.

19. I have the drive and energy to take action in my business.

20. It's safe and appropriate for me to take action and move forward.

21. I act calmly and decisively and with clear focus.

22. I set clear and specific goals and I take action toward achieving them.

23. I take consistent, inspired action in my business.

24. My actions are rooted in my clear vision for my business.

25. I easily create with focus and divine inspiration.

26. I'm so excited to launch [name of product or service] to the world.

27. I take action when inspiration comes to me.

28. Taking action builds my confidence and courage.

29. I live in the flow of my life purpose, and my actions are easy to take.

30. It's easy and effortless for me to take action toward my business goals.

31. I easily follow through and complete all my projects.

32. I easily maintain the perfect balance between work and play.

33. All my actions support my goals and dreams.

34. I act on every opportunity that is aligned with my vision.

35. I enjoy taking action and getting things done.

36. I take responsibility for my business by taking inspired action every day.

37. Every inspired action I take creates wonderful new opportunities for me.

38. With each action I take, I become more inspired and motivated.

39. I easily create [name of product, project, or service] now.

40. I'm both efficient with and respectful of time.

41. I work smartly and at lightning speed.

42. I have all the energy I need and more to do the things I want to do.

43. I am super energized into action.

44. Focus is easy for me.

45. I always focus on my highest priority actions.

46. I quickly and easily take action on my ideas.

47. I move forward fearlessly in my life and business.

48. I advance toward my goals deliberately, methodically, and at exactly the right pace.

49. I visualize it and then I do it.

50. It's safe and appropriate for me to listen to and take action on my intuition.

51. I have more than enough time to do all the things I want to do.

52. I relax and take time to respond to difficult messages.

53. I easily take care of all the work needed to make [£€$ amount of money] each month.

54. It's always easy for me to make time to [complete a specific action].

55. Taking action is easy and fun for me.

56. I release stress from my life as I take action with ease.

57. I release stress from my life as I achieve my goals with ease.

58. The more actions I take, the better I feel about myself and my business.

59. I take easy inspired action to achieve my business goals.

60. Inspired action is easy when I listen to my intuition.

61. I take the right actions for me and my business.

62. I release the need for busy work and always focus on high-priority actions.

63. I easily focus on the high-priority goals in my business.

64. I easily set goals with appropriate and achievable deadlines.

CHANGE AND GROWTH

1. Change can be really quick for me.

2. I feel calm, focused, happy, secure and serene when changes are happening.

3. I look forward to change in my life and business.

4. I easily embrace and adapt to change in my business.

5. I welcome changes in my life and business.

6. I am a catalyst for my own change.

7. I am willing to take the necessary risks to change.

8. Change is my friend, as it helps me experience new and exciting things.

9. I enjoy and accept the process of change, including the difficult parts.

10. I actively embrace the opportunities that come with change.

11. I have the power to easily change my business.

12. Change is easy and effortless for me, and I enjoy it.

13. My arms are open to change.

14. It's safe for me to let go of my current business and begin a new one.

15. It's safe and appropriate for my business to change as I do.

16. Change represents freedom and flow and I love it.

17. I have the clarity of vision to see the signs of change and I take action on them.

18. My business evolves and grows as I do.

19. I am agile and I easily change when circumstances call for it.

20. Change helps me learn and grow and I embrace it.

21. I take the necessary risks to change my business when I feel it's time to do so.

22. Change always brings new opportunities and gifts to me.

23. Change helps me grow and evolve as an individual.

24. As I transform myself and my mind, my business transforms.

25. I accept change when it happens.

26. My ability to easily change allows me freedom in life and business.

27. I easily change my business to align it with my values.

28. Change is always positive, as it brings new things to my life and business.

29. My business and I are constantly changing and transforming as we grow.

30. As I change, I feel in flow with my purpose.

31. I love change; it helps me flow with my own personal transformation.

32. My business is expanding and flourishing.

33. It's my time and I'm ready for the next step.

34. My business gives me the perfect opportunities to learn and grow.

35. My business grows easily and effortlessly.

36. I adapt to changes in my life and business easily and effortlessly.

37. I am the most advanced professional version of myself that I can be.

38. It's possible to grow both myself and my business at the same time.

39. I easily rise up to the level of the person I want to be.

40. I am the person I want to be.

41. I easily let go of all that no longer serves me.

42. It's safe and appropriate for me to let go of old friends that I've outgrown.

43. I easily let go of old structures and allow joyful energy to flow through me.

44. I easily release all limitations and allow myself to flourish.

45. I easily break through all limiting boundaries.

46. I blossom like the glorious flower I am.

47. I easily let go of past teachers, mentors, and coaches that I've outgrown.

48. I easily grow and transform my life.

49. I easily reinvent myself.

50. It's easy for me to try on new ways of being.

51. I accept and welcome the changes in my life.

52. I easily trust the process of change and growth.

53. I feel comfortable and excited when going through a transition.

54. My business is growing in accordance with divine timing.

55. Change is easy and fun for me.

56. I release stress from my life as I make changes in my business.

57. Change is stress-free in my business and life.

58. The more inspired changes I make, the better I feel about myself and my business.

59. I take easy inspired action to make changes in my business and life.

60. I take easy inspired action to grow myself and my business.

CLIENTS AND BOUNDARIES

1. I ask all clients for a referral and a testimonial.

2. People are very excited to do business with me!

3, I feel calm and self-assured on my discovery calls.

4. I give people more than they expect and I am happy to do this.

5. I attract loyal clients to my business who recommend me to others.

6. I have a successful business that improves lives, including mine.

7. It's easy for me to bring in a consistent stream of clients each month.

8. Because I am such a positive resource, people love doing business with me.

9. I am in tune with my clients' needs.

10. I have an excellent business reputation that is backed up with client testimonials.

11. I provide products and services that my target market of clients wants and needs.

12. I have healthy boundaries with my clients.

13. The things I create in business serve to help others.

14. It's easy and effortless for me to attract the right clients for my business.

15. Potential clients trust me because I am trustworthy.

16. I'm capable of helping my ideal clients go from good to great.

17. It's easy and effortless for me to attract clients who are prepared to invest in what I have to offer.

18. I have a steady stream of clients committed to working with me this year.

19. I take responsibility for my relationships with my clients.

20. People recognize that the products and services I create have great benefits.

21. It's easy for me to attract the right people to my business.

22. I have a steady stream of clients who keep coming back for more.

23. My ideal clients easily understand the value of what I have to offer.

24. I attract new paying clients on a daily basis.

25. It's easy for me to communicate my new higher fees to clients.

26. My ideal clients are happy to pay the prices I ask.

27. I attract only uplifting and inspiring clients to my business.

28. When my ideal clients first meet me, they feel instantly drawn to me.

29. My paying clients are 100% happy with the results they get from working with me.

30. It's safe and appropriate for me to take all the time I need to give a quote.

31. It's safe and appropriate for me to channel people to my services and this is easy for me.

32. Boundaries help me create a win-win situation with my clients.

33. I know exactly who my ideal client is and how to communicate with them.

34. It's okay for me to let go of clients who aren't a good fit.

35. I quickly and easily let go of clients when I sense we aren't a good fit.

36. It's easy for me to collect money from clients who need to pay their invoice.

37. It's easy for me to connect with my ideal clients.

38. I have a steady stream of clients who pay for what I love to do.

39. I am booked out with clients for months in advance.

40. I write compelling content that gets me seen online.

41. The more people who know about me, the more people I can help.

42. I attract clients who appreciate me and my work.

43. I have strong boundaries and I communicate them clearly and with love.

44. I have a constant stream of clients who pay me well.

45. I have an easy system for sending contracts to clients.

46. It's easy for me to ask clients to sign contracts.

47. It's easy for me to ask for client referrals.

48. I perfectly manifest a steady stream of clients.

49. I consistently attract clients who see the value in what I have to offer.

50. People pay to hear my message.

51. People want what I have.

52. People are attracted to what I embody.

53. People are longing for what I have to offer.

54. I have the wisdom to know what to change.

55. It's easy for me to find clients who are ready, willing, and able to take action.

56. It's easy for me to fill my calendar with paying clients.

57. Signing up new clients is an easy and streamlined process.

58. I have a client management system that builds great relationships.

59. My ideal clients keep coming back for more.

60. I only attract clients who are a great fit for me.

61. I easily set and uphold boundaries with my clients.

62. I set and uphold clear boundaries regarding client cancellations.

63. I fully value my time and energy, and so do my clients.

64. I attract clients who value my time and work.

65. My clients always reschedule appointments well in advance when they need to.

66. I appreciate and respect my time, and so do my clients.

67. The more I respect my time, the more I encourage my clients to respect their own time.

CONFIDENCE & TRUST

1. I am confident and humble.

2. The more confident I am, the more I can be of service to others.

3. There is a way to be both confident and humble and I open myself to the solution now.

4. I am a woman of strength and courage.

5. I am good at business and I have great business sense.

6. I believe in my ability to change the world with the work that I do.

7. I am capable of running my own successful business.

8. I'm confident in what I have to offer clients.

9. I'm confident in my knowledge and experience.

10. I'm confident about asking people to JV with me for business.

11. I let go of all fears of being powerful and successful and replace them with confidence.

12. I am here to fully express myself.

13. I believe in myself, my power, and my abilities.

14. I am confident.

15. I have full trust and belief in myself.

16. I am trustworthy and reliable.

17. I am self-confident and self-assured.

18. I can rely on myself and I do.

19. I trust myself to make the business and life decisions that are for my highest good.

20. I feel powerful and confident when speaking.

21. I am sure of myself.

22. It is safe and appropriate for me to be confident and sure of myself.

23. I have courage and I take action accordingly.

24. I am determined to be successful.

25. I trust each and every decision I make.

26. I trust my business to support me.

27. I feel safe, comfortable, and equal in groups.

28. I have faith in myself.

29. I believe in myself and my ability to make a successful business on my terms.

30. I am tenacious.

31. I'm an inspiring and financially successful business woman.

32. I believe in myself and so do other people.

33. I have total faith in myself that I can achieve my business goals.

34. I believe I can make things happen.

35. I am an expert in my field and my ideal clients view me as such.

36. I have all I need to create a successful business.

37. I have the time and energy to create a successful business.

38. I am confident and comfortable with myself.

39. I am quirky and different and I have the confidence to express my differences.

40. I am megaconfident.

41. I easily and confidently express my woo side.

42. I have a well established line of trust with myself.

43. I easily listen to my heart and its wisdom.

44. I believe in myself and my enormous potential.

45. I deeply and completely believe in myself.

46. I trust in my ability to hold space for people.

47. I trust that I can handle myself in case of emergency.

48. I trust I can handle anything that comes my way when I'm holding space for a group.

49. I trust in my ability to create something totally new.

50. I trust in my ability to recognize and receive downloads.

51. I trust myself to remember all the details from my downloads.

52. I deeply and completely trust myself.

53. I trust in my ability to [insert action of choice].

54. I am safe, confident, and secure in my life.

55. I trust that each step I take is perfectly guided.

56. I trust my inner self.

57. I have invincible confidence in myself.

58. I deeply and completely trust my intuition and always act on it.

59. I confidently position myself as an intuitive business owner.

60. I easily remain connected to my intuition.

61. I release the need for approval and replace it with trust in my own decisions.

CREATIVITY

1. My writing is deep and heartfelt.

2. I am highly creative in business and in life.

3. I easily open up and express myself clearly in my creative projects.

4. My mind is open to new creative ideas and inspiration.

5. An endless flow of creativity lies within me.

6. I am always open to creative ideas, thoughts, and perspectives.

7. Expressing my creativity through business gives me great joy.

8. I am a naturally creative person.

9. My business is the perfect way for me to express my creativity.

10. My creativity flows easily and effortlessly.

11. Brilliant business ideas come to me all the time.

12. I am full of inspiration and creativity.

13. Creative energy flows through me every day.

14. I creatively express myself with ease.

15. Creative business ideas come to me regularly.

16. My creative ideas shape how my business grows.

17. With each day I become more creative in business and in life.

18. I am becoming more and more creative with every day.

19. New business ideas flow to me daily.

20. My creative gifts are appreciated by my ideal clients.

21. I allow my creative energy to flow freely at all times.

22. I release all resistance to fully expressing my creativity and I replace it with acceptance.

23. I always pay attention to my creative inspiration.

24. I am a successful writer, and I am extremely creative with words.

25. I am a creative problem-solver in business and in life.

26. It's easy and effortless for me to express my creativity through writing.

27. I am a creative visionary in business.

28. My mind is filled with creative ideas.

29. My writing is strengthened by constructive criticism and editing.

30. I express my creativity every day, with confidence and enthusiasm.

31. I deserve the time and space to be creative and inspired.

32. I channel my creativity into successful and profitable projects.

LEADERSHIP AND OUTSOURCING

1. I lead from femininity.

2. I know how to lead in life and business.

3. My ideal clients recognize me as a leader in my field.

4. My tribe trusts my opinions and expertise.

5. It's easy for me to take the lead in business and in life.

6. I am a natural strategic decision maker.

7. I have excellent leadership skills.

8. I regularly seek out new leadership opportunities.

9. I am a born leader and leadership comes easily to me.

10. I embrace responsibility and leadership.

11. I make things happen.

12. I am an inspiring mentor to other entrepreneurs.

13. I inspire others to greatness.

14. I inspire my team to reach their goals.

15. I enjoy working with other people to achieve my business goals.

16. I love being an inspiration to others.

17. My story of personal and professional freedom inspires others to seek the same.

18. My words inspire people all over the world.

19. I inspire others to make a difference in the world.

20. It's easy for me to communicate my vision to my team.

21. I get help when needed to make my business a success.

22. I'm a great entrepreneur and I treat my service providers exceptionally well.

23. I deserve to outsource the things I don't enjoy doing, like housekeeping and admin work.

24. My business can easily support all the staff I need and provide me with free time to enjoy my life.

25. It's safe and appropriate to let my team support me.

26. It's easy to find the perfect freelancers to help me with my business.

27. I have a clear vision of exactly who I need to help me with my business.

28. It's easy for me to find the right person to build process and systems for my business.

29. I'm able to provide a stable work environment for my employees/freelancers.

30. I attract employees/freelancers who are loyal to me and my business.

31. I am an outstanding leader in my field.

32. It's easy for me to create a compelling vision that my team members and I are excited about.

33. I hire people for their strengths and I find ways to support their weaknesses.

34. Collaborating with other entrepreneurs is more fun and profitable than competing with them.

35. I am inspired by the accomplishments of other entre-preneurs.

36. I am fully supported in my vision for my business.

37. It's easy for me to accept help from others.

38. It's safe for me to accept help from other people.

39. It's easy for me to delegate whenever I need to.

40. I can tell who I can trust to delegate to and it's safe to do so.

41. I easily find people who can do things better than me.

42. My greatness shines through my work and my leadership.

43. I trust that I know when and how to delegate tasks.

44. I trust in my ability to manage people so that quality work gets done.

45. I am a thought leader for the change in consciousness.

46. I'm part of the change in consciousness revolution.

47. I have a big role to play and I can do it.

48. Other people are ready, willing, and able to support me.

49. I am known worldwide for [your field of expertise].

50. I am a leader in [your field of expertise].

51. I fully embrace my purpose as a path-maker.

52. I shine my light as a positive authority figure.

53. It's easy for me to ask for and accept help.

54. I'm seen as an expert in my field.

55. I am an expert in my field.

56. It's easy for me to focus on my zone of genius and to outsource the rest.

57. I spend my work days focused on my zone of genius.

58. I have a talented team of people who help me with tasks that are outside my area of expertise.

59. I love building and managing my team of talented people.

60. I'm great at managing the people on my team.

LEARNING

1. Technology comes to me easily and effortlessly.

2. I easily embrace new concepts and ideas.

3. It's easy for me to learn new things.

4. I love learning new things.

5. Any information I need to recall comes effortlessly to mind.

6. I easily learn anything I need to know.

7. Every day I improve my ability to retain information.

8. Each day I learn something new and exciting.

9. I easily absorb new knowledge and concepts.

10. I am able to remember all information when needed with ease and clarity.

11. I am eager to learn new things for my business.

12. I embrace the idea that being an entrepreneur involves learning new things.

13. I am completely at ease when learning new concepts.

14. I am fully committed to learning what I need to learn to make my business a success.

15. I am motivated to learn new things and I am confident in my ability to retain new information.

16. I love learning about business and marketing.

17. I love that owning a business means I get to learn new things.

18. Being an entrepreneur means that I am constantly learning.

19. I have a great business mentor who guides me to learn new things.

20. My business mentor helps me learn what I need to grow my business.

21. Learning is easy when I have a business mentor who is aligned with my values.

22. Learning is fun and exciting!

23. Learning new things opens my mind to new concepts and ideas.

24. It's easy for me to understand what my preferred method of learning is.

25. I clearly see what I need to learn in my business and I take action toward learning it.

26. I am inspired by other entrepreneurs and easily learn from them.

27. I easily learn from other business owners.

28. I am free to learn all I need to know in my business.

29. I choose to learn quickly and easily.

30. I love and accept my mind's natural ability to learn.

31. It is okay for me to want to learn more and grow.

32. It's easy for me to learn from others.

33. I quickly learn from all my business relationships.

34. I am clear about what I want from a coaching/mentoring relationship.

35. I feel safe and powerful when I outsource tasks in my business.

36. I rise to the challenge of technology and use it well.

37. I accept my imperfections as opportunities to learn valuable lessons in my life.

LIFESTYLE

1. My business gives me the financial freedom to travel whenever I want.

2. I have a business and lifestyle that I love.

3. I experience freedom on a daily basis.

4. I'm doing what I always wanted, thanks to my business.

5. I make my dreams a reality and live my ultimate lifestyle.

6. I enjoy my business and I am fulfilled by the work that I do.

7. My business brings me great joy.

8. I contribute to the world in a meaningful way, and I am paid back a million-fold.

9. I choose a business that impacts this world in a positive way.

10. I have a happy life outside my business.

11. I can have a multimillion dollar/pound/euro business and still have plenty of free time.

12. It's possible for me to have a successful business and a good relationship with a man/woman.

13. It's easy for me to have a successful business and still have as much space and time for myself as I want.

14. Running my business is easy and nourishing.

15. I am grateful for the life and work that I do.

16. It's easy for me to upgrade the things I own to better quality items.

17. My ultimate lifestyle is easy to achieve.

18. It's easy for me to make time for self-care.

19. I live a first class life and I offer a first class service to my clients.

20. I make enough money to have a weekly housekeeper.

21. My business allows me to live my life purpose.

22. My business allows me to express myself fully.

23. The Universe/God willingly helps me to create my ideal lifestyle.

24. I deserve to have the lifestyle I want.

25. It's safe and appropriate to have the lifestyle of my dreams.

26. I am free to create my ideal lifestyle.

27. I choose to have a vibrant, exciting life.

28. I see beauty in all parts of my life.

29. It's safe and appropriate for me to prioritize my own needs.

30. I take action to create my ideal lifestyle.

31. I build my ideal lifestyle in alignment with my inspired vision.

32. I am ready, willing, and able to create the life of my dreams.

33. It's easy for me to build my ultimate lifestyle.

34. I am worthy of living a satisfying, exciting life.

35. It's safe and appropriate for me to be free.

36. I make time to play in business and in life.

37. I easily find and connect with people who support my life of financial freedom.

38. I live in harmony with my business.

39. I live a happy, joyful, and prosperous life.

40. I live a healthy, wealthy, and enriched life.

41. I live an abundant and generous lifestyle.

42. It's easy for me to have fun.

43. It's easy for me to disconnect from work.

44. It's easy for me to go on holidays.

45. I live and travel with a first class mindset.

46. It's safe and appropriate to relax.

47. I protect myself with self-care.

48. Self-care is the best protection for me.

49. I easily attract all that I desire.

50. I live in a self-aware and fully autonomous way.

51. I live in a carefree manner because I know that everything is taken care of.

52. When I live trustingly, only good things happen to me.

53. I live a life of flow.

54. My life is full of grace and peace.

55. I slow down and see the beauty around me.

56. I savor and enjoy each moment.

57. I am happy in every moment of every day.

58. I am aware of life's everyday miracles.

59. I make space for quiet time in my life.

60. I am joyful about my present and my future.

61. Everything is in divine and perfect order, right now and always.

62. Everything I need is provided to me, always.

63. I allow myself all the quiet time I need.

64. I make quiet time a priority.

65. I take full responsibility for fulfilling my life and dreams.

66. It's easy for me to visualize the lifestyle of my dreams.

67. I value freedom and I feel it every day in my business.

68. I take good care of my body.

69. I feel pleasure and abundance with every breath I take.

70. I am very fortunate to work at what I love to do.

71. My life and business are an expression of my playful nature and I love them!

72. I connect easily and often to nature.

73. I am safe always, and I am loved.

74. I trust in the process of life.

75. I am deeply nourished by nature.

76. Abundance makes my life easier.

77. I graciously walk away from conflict.

78. I allow my mind to relax and be at peace.

79. The world is a safe place for me.

80. Surviving and thriving is easy and effortless for me.

81. It's easy for me to survive and thrive in this world.

82. I thrive the most when I work and exercise in a balanced way.

83. It's easy for me to work in a balanced way.

84. It's safe and appropriate for me to work in a balanced way.

85. It's easy for me to live a balanced life.

MARKETING & SALES

1. I receive regular invitations to speak.

2. I make sure every sale lays the foundation for the next sale.

3. I have a funnel filled with quality prospects and leads.

4. My profits increase weekly.

5. I turn every business transaction into one that is mutually beneficial for myself and for my clients.

6. I take action to build my online tribe via blogging and social media.

7. I enjoy business networking and I find it easy and effortless to network with others.

8. I always spot opportunities to network for my business.

9. I am well connected with an extensive business network.

10. I am skilled at selling my products and services to others.

11. It's okay for people to say no to me.

12. When I speak, my ideal clients feel compelled to sign up with me.

13. I am a fantastic salesperson and my ideal clients say yes to working with me.

14. It energizes me to market myself and my business.

15. It's safe to be rejected.

16. It's easy for me to attract my target number of people for my programs and events.

17. It's easy to receive invitations to speaking opportunities.

18. I effectively and efficiently use social media to bring in paying clients.

19. I am a confident and engaging public speaker.

20. I easily accept opportunities to promote my business.

21. It's safe for people to say no to me.

22. It's okay when people reject my offerings.

23. Selling from speaking and webinars is easy and effortless for me.

24. I'm an excellent salesperson who always sells congruently.

25. I feel congruent and comfortable during sales conversations.

26. I am in control of my sales process.

27. I have a structured sales conversation that I effortlessly guide people through.

28. I am clear about the unique benefits of the products and services that I offer.

29. I believe that my products and services can make a difference to my ideal clients.

30. I have a clear vision of who my ideal client is and what s/he is like.

31. I create a good first impression whenever I meet people online and offline.

32. I love networking to meet new people and get new clients.

33. Potential clients feel certainty and safety when speaking to me about my offerings.

34. I clearly communicate the value of my products and services.

35. I am comfortable being a salesperson.

36. I am comfortable selling my products and services.

37. It's easy and comfortable for me to express who I am in my business.

38. It's safe and appropriate for me and my business to take up space.

39. I feel comfortable and confident delivering powerful content via webinar.

40. It's easy for me to invest in marketing my business.

41. It's easy for me to be consistent in my marketing.

42. I easily write and send weekly newsletters to my list.

43. I easily and clearly express the value of all my offerings.

44. It's safe and appropriate for people to question my prices.

45. I easily call people into my orbit.

46. People understand me.

47. I love [doing videos/recording podcast episodes/writing blog posts] for my business.

48. It's easy for me to batch and release [videos/podcast episodes/blog posts] for my business.

49. It's easy for me to fit [videos/podcast episodes/blog posts] into my schedule.

50. Building a thriving [YouTube channel/podcast/blog/Facebook group/etc.] is important to the success of my business.

51. I have a super successful [YouTube channel/podcast/blog/etc.] with tens of thousands of subscribers.

52. I'm skilled at setting up powerful Facebook ads that abundantly feed my sales funnels.

53. I regularly write guest blog posts for other people to increase my reach.

54. I have an eager team of affiliates who promote my work for a commission.

55. My gorgeous website clearly reflects the power of the work I do.

56. My powerful website regularly fills my sales funnels with clients.

57. I have an active and engaged email list of people who love my work.

58. I have an easy-to-manage editorial calendar for my content.

59. Sales conversations are easy and fun for me.

60. I get excited for my sales conversations.

61. Marketing is fun and enjoyable for me.

MONEY

1. Money is Divine.

2. I am spiritually and financially rich.

3. Money flows to me regularly and consistently.

4. I'm responsible with money and I run a profitable business.

5. I have all the money I need and more.

6. I'm great at saving and investing money.

7. Money flows to me in amounts greater than my need.

8. I have a great relationship with money.

9. It's easy for me to make a lot of money.

10. It's okay to spend money.

11. I focus only on what's important to enable money to come to me easily.

12. It's easy for me to receive.

13. I know what's important and effective to enable money to come to me easily.

14. I love money and money loves me.

15. I am financially independent and I love it.

16. I am relaxed about money.

17. The more money I have, the more money I have to give.

18. I appreciate and value money.

19. I always have more money than I need.

20. I can be trusted with money.

21. I trust the Universe/God to provide for me.

22. It's easy for me to bring in money during my transition period.

23. I have an abundance of resources available to me.

24. I live in a world of plenty.

25. I trust that money comes when I want it.

26. It's safe for me to be wealthy and use my money for the highest good.

27. I constantly attract more abundance.

28. It's easy for me to get paid for my knowledge.

29. Money comes to me easily and effortlessly.

30. I love money and I believe that money is important.

31. I enjoy abundance and plenty.

32. I love feeling wealthy.

33. I am financially responsible.

34. I am great at managing my money and making it multiply.

35. I am financially successful.

36. Money can come to me in fun ways.

37. I am financially independent.

38. I transform and manifest my financial reality.

39. I am responsible for my financial situation.

40. I do good things with the money I make: I donate 10% of income to Kiva, I save 10% for investments, and I spend 10% on fun things.

41. I have enough money to reinvest in my business to

help it grow.

42. I am a magnet for money and success.

43. It's safe and appropriate to make a lot of money quickly and easily.

44. It's easy for me to make money when I'm having fun.

45. It's safe and appropriate for me to receive large sums of money.

46. Creating revenue is easy and I have zero debt.

47. I always have more than enough money to pay my rent and my bills.

48. I can make all the money I want from my business.

49. Money is good, and I love it!

50. I deserve money and I always have more than enough.

51. The Universe/God is constantly magnetizing money to me.

52. I receive my wealth and abundance with ease, grace, and gratitude.

53. It's safe and appropriate for me to ask for the money I want in exchange for my services.

54. More money helps me to make a difference in the world.

55. It's safe and appropriate for me to make money in my business, even when other people are in need.

56. It's easy for me to remember to track all the money that comes to me.

57. It's easy for me to save money.

58. It's safe and appropriate for me to check my bank balance on a regular basis.

59. It's easy for me to live a debt-free life.

60. I trust myself to be responsible with my money.

61. Money is a way for me to make a difference in the world by helping others.

62. The more money I have, the more people I can help.

63. It's safe and appropriate for me to have more money than I need.

64. I am free to want money.

65. I choose to live a wealthy life.

66. I love and accept my bank account, no matter what the balance is.

67. I am grateful for the money I do have.

68. I release my painful money story and eagerly look forward to money flowing into my life.

69. Although I grieve for money I have lost, I am trusting and confident that more money is coming to me.

70. I forgive myself for how I handle money, and I trust myself to manage money sensibly.

71. I bless and release all those who have caused me financial distress.

72. It's easy for me to say no, even when money is involved.

73. I have the freedom to change my prices whenever I want.

74. It's safe and appropriate for me to receive money for doing what I love.

75. I generate enough income that being in business is worthwhile for me.

76. It's safe and appropriate for me to charge more for my services than other people.

77. My business consistently supports me in ever increasing amounts.

78. I open myself up to receive money and abundance.

79. I am worthy of receiving money and abundance.

80. Money is safe.

81. I make and sustain wealth easily.

82. I can help others more if I meet my own needs first.

83. I am talented with money and investments.

84. I look after my money wisely.

85. I always make more money than I need from my work.

86. It's easy for me to set and achieve challenging money goals.

87. Making money is a priority for me.

88. I easily pay off my credit cards in full every month.

89. I have a savings account with lots of money in it.

90. It's easy for me to keep money in my bank account.

91. It's easy for me to live a debt-free life.

92. I am financially savvy.

93. I easily handle my own finances.

94. I keep on top of all my bookkeeping and taxes.

95. I love looking at my bank account.

96. It's safe and appropriate for me to charge whatever prices I want.

97. It's safe and appropriate for me to trust my prices.

98. I can be trusted with lots and lots of money.

99. I can be trusted with millions of pounds/dollars/euros.

100. My natural relationship with money is responsible.

101. The more freedom I feel, the more money I make.

102. The more I travel, the more money I make.

103. I easily resolve any money problems by getting more clients.

104. I deserve more money.

105. I have an intrinsic ability to increase my wealthy by being me and sharing my message.

106. It's easy for me to imagine receiving large amounts of money.

107. It's easy for me to receive large amounts of money.

108. It's easy for me to support myself financially.

109. I am ready to have all the riches I desire.

110. I am open to receive all the money I need to be free.

111. I easily maintain and grow my income while doing deep healing work.

PERSONAL POWER

1. I stand authentically in my power.

2. I'm safe and powerful in the world.

3. I express my personal power in everything I do in my business.

4. I have a deep belief in my own personal power and my ability to help people.

5. I take the initiative to create my life the way I want it.

6. I have the power to make my vision and dreams come true.

7. I am true to my personal vision and I take action toward it.

8. I easily speak my personal truth with clarity and confidence.

9. Taking action when I'm afraid gives me power.

10. I give myself permission to do what I love and want.

11. I accept and cherish the power within me.

12. I make a difference in the world.

13. I have a powerful personality and people are attracted to me.

14. I have the power to realize my life purpose through my business.

15. I trust every business decision that I make.

16. I trust my ability to make good decisions for my business and life.

17. I accept and embrace the power within me.

18. I easily and effortlessly take charge in my life.

19. I am in full control of my mind, my body, and my life.

20. When I take responsibility for my life, my sense of personal power grows.

21. I am comfortable and powerful in my own skin.

22. I am in charge of my own life.

23. I am powerful and decisive in all that I do.

24. I have the power to take care of myself.

25. My personal power helps me to easily change and adapt when needed.

26. My sense of personal power is soft and flowing.

27. I feel a strong connection to my personal power.

28. I work to my strengths, and this increases my personal power.

29. I quickly and easily get help to support my weaknesses, and this makes me stronger.

30. I feel a strong sense of courage and conviction.

31. I own my personal power and I take responsibility for everything I experience.

32. I take responsibility for my life experience.

33. My clear sense of personal power is attractive to others.

34. It feels strong and powerful to be me.

35. I easily step into my power and express myself.

36. It's safe for me to take radical actions in my business.

37. I have the power to stand my own ground in the face of disagreement.

38. I kindly and easily speak my truth at all times.

39. I have permission to be different.

40. My power is in my differences.

41. I am assertive in all domains of my business and life.

42. I have the power to change.

43. It's easy for me to say no when other people want things from me.

44. It's easy for me to ask for what I need.

45. I live with faith, courage, and strength.

46. When I put myself first, I can handle anything that comes my way.

47. I always put my own needs first.

48. I trust I always make the best decisions for me.

49. I remain calm and grounded at all times.

50. I easily create and uphold boundaries that allow me to elevate myself.

51. I'm capable of being powerful.

52. I'm worthy of being powerful.

53. I'm ready, willing, and able to be powerful.

54. People trust me.

55. I have powerful energy.

56. My energy comes through in a big way.

57. I own my powerful energy.

58. I am strong, powerful, and grounded in every way.

59. It's easy for me to step into a higher vibration of energy.

60. Boundaries can be gentle and calm.

61. I am intuitively open to my deepest self.

62. I am deeply and firmly rooted in myself.

63. I am fully present and grounded in my body.

64. I know I am protected, now and always.

65. I take full responsibility for my life.

66. I easily step into my greatness.

67. People want to be in my presence.

68. I walk through the world with my stage energy.

69. I am a conduit for the Divine.

70. I embody the fullness of all that I am.

71. I have what it takes to do this work.

72. My humor makes me approachable.

73. When I use humor it's a magnet for people.

74. I embody my stage energy every day.

75. I speak my truth easily and transparently.

76. I am a visionary.

77. I am powerful and strong.

78. I am all that I need.

79. All that I need is within me.

80. I easily tap into the knowledge of the universe and allow myself to receive.

81. I easily create miracles in my life.

82. I am ready, willing, and able to receive miracles in my life.

83. I am fully coherent in all that I do.

84. My true self is awake and alive.

85. I know exactly who my true self is.

86. I live my true self every day of my life.

87. I have strong and healthy boundaries.

88. I am a divine being of light.

89. I am present in my body and all is well.

90. I fully claim my whole, brilliant self.

91. I fully step into my brilliant magnificence.

92. It's easy for me to shine, light up, and just go for it.

93. I easily open up to and connect with my complete self.

94. I fully embrace my superpowers.

95. I am a limitless expression of [God's/the goddess's/the Universe's/etc.] love.

STRATEGY, CLARITY AND VISION

1. I have a clear business plan.

2. I have brilliant business ideas.

3. I can overcome any challenge in my business.

4. I am decisive rather than doubtful.

5. I have a killer business idea that appeals to my ideal clients, and I know what that is.

6. I have clear plans for revenue streams that clients want.

7. I have a clear business model that people want now.

8. I make decisions based on my values.

9. It's easy for me to imagine a business model that is fun.

10. I have a clear vision for my business which is aligned with my purpose.

11. I see clear and obvious signs that guide me along my path.

12. I have a clear marketing strategy for my business and I'm fully confident that it works.

13. I let go of the need for approval from others and I do what I think is right in my business.

14. It's easy and effortless to realize my vision.

15. Creating my global vision is stress free.

16. I have absolute clarity on how to run my business.

17. I'm clear about what I want in my business and I follow my intuition.

18. My mind is calm and clear.

19. It's easy for me to see the highest priorities in my life and business.

20. Everything I need to know is clearly revealed to me.

21. My vision for my business is based on my life purpose.

22. I have a clear vision on how I want to run my business.

23. My divine wisdom guides my clear vision.

24. My inner vision is always clear and focused.

25. It's easy for me to see the signs that mark my journey through life and business.

26. I easily create a business I love to look at.

27. I feel blessed with absolute clarity.

28. My purpose is clear and I can see my path open before me.

29. I clearly see my gifts, skills, and abilities and I offer them through my business.

30. My mind is clear and focused.

31. I can see clearly now and I take steps down my path.

32. My life purpose is clear to me, and I easily follow it.

33. The bigger I believe, the bigger I achieve.

34. I easily see the next step toward my goals, and I take it.

35. I invest in the best business mentors and coaches to help me grow my business.

36. I have a clear plan for business success.

37. It's safe and appropriate for me to focus on my highest path.

38. I have absolute clarity about what I'm doing and offering in my business.

39. It's easy for me to turn my business ideas into money-making products and services.

40. I feel abundant regardless of how much money is in my bank account.

41. I have a variety of passive income streams in my business.

42. I feel comfortable taking risks in business and in life.

43. I am naturally insightful and innovative.

44. It's safe and appropriate for me to invest in my business.

45. My beliefs and my actions shape my business.

46. I always know the right time to launch a new product.

47. All of my skills are coming together into a cohesive vision.

48. It's easy for me to be organized in my business.

49. I'm organized and prepared well in advance for my webinars and workshops.

50. It's easy for me to know what I want, to ask for it, and to have it.

51. My life is full of ease and flow.

52. My business is full of ease and flow.

53. I have multiple highly successful sales funnels.

54. I have a clear understanding of how to create the right sales funnels for my business.

55. My vision and mindset are constantly upleveling.

56. I am clear in my message.

57. I easily make play a part of my work.

58. My work is fun and playful.

59. Negotiating is easy for me.

60. I feel good about backing out of responsibilities that no longer serve me.

61. I choose my own direction resolutely.

62. I have patience as my dreams come together.

63. I enjoy the process of realizing my dreams.

64. I feel gratitude every step of the way.

65. I open myself up to receive big downloads.

66. I give myself the time and space to receive big downloads.

67. I know where I'm going at all times.

68. I easily see the next step on my journey.

69. I let go of all my fears as I take big steps forward.

70. I have an open mind and am ready for downloads.

71. I know exactly what makes my heart sing.

72. I know exactly what I want to get out of my life.

73. I know exactly what it is that I want to do with my business.

74. I know my calling and the work I am supposed to do in my life.

75. I always know what to do in any situation.

76. I celebrate my knowledge and I allow myself to think whatever I want to think.

77. I let my thoughts soar high.

78. When faced with an obstacle, I easily flow around it.

79. I know I can easily overcome any obstacle in life and business.

80. It's easy for me to find simple solutions to complicated problems.

81. I observe everything that happens in a state of peace and nonattachment.

82. Clarity and harmony are within me and around me, and all is well.

83. I easily check in with my soul and see who I am.

SUCCESS AND OPPORTUNITIES

1. I am extraordinarily successful on my own terms.

2. It's safe and appropriate for me to be successful.

3. I appreciate the success I have.

4. I feel safe and successful now.

5. I am confident in my success.

6. I appreciate my success.

7. I am comfortable with my own success.

8. I accept how successful I am.

9. I am good enough to be successful.

10. I have a wildly successful business.

11. I am a successful entrepreneur.

12. My experience and expertise help me to be successful.

13. I am disciplined and determined to succeed.

14. The important people in my life will support me in my success.

15. It's safe and appropriate for me to share my business successes.

16. It's easy for me to succeed in life and business.

17. Success means acting with integrity and making a difference.

18. I choose to be successful in my business and I am open to it.

19. I am safe even when people feel threatened by my success.

20. My true friends support me in my success.

21. I am wildly successful beyond my dreams.

22. I enjoy experiencing unexpected successes and pleasant surprises.

23. I embrace opportunity and abundance in my business.

24. New opportunities come easily to me.

25. Opportunities for financial growth continue to come my way.

26. My business is full of opportunities.

27. I am a full time, successful entrepreneur.

28. I am a best-selling author whose books drive clients to my business.

29. Having a business coach/mentor helps my business be successful.

30. It's easy for me to talk about my successes with others.

31. I feel confident and deserving when sharing my successes.

32. I am deserving of success.

33. I love feeling successful.

34. I feel joyously successful.

35. I am free to have sustainable success in my business and life.

36. Business success is easy and natural for me.

37. I am happy with where I am right now in my business.

38. I am inspired by other entrepreneurs in my field.

39. I am a successful and inspired entrepreneur.

40. It's safe for myself and others to see my full potential.

41. It's safe for me to realize my full potential.

42. It's easy for me to realize my full potential.

43. I achieve all my goals easily and rapidly.

44. I achieve greatness and success.

45. I give myself permission to celebrate my own successes.

46. I am grateful for all I have and for all I receive.

47. I notice and embrace the new opportunities that are now in my life.

48. I always balance giving and receiving.

49. It's easy for me to reward myself for my work.

50. I magnetically attract success, wealth, and opportunities.

51. I achieve something extraordinary every day.

52. My business takes off like a rocket.

53. I successfully grow my business and I am compensated for my efforts.

54. My clear intuition drives my business success.

55. The more I act on my intuition, the more success I enjoy.

56. My success is linked to my ability to be me.

57. The more I am me, the more abundance I enjoy.

58. I relax into the feeling of abundance and allow it to magnify easily.

59. The more I listen to my intuition, the more I increase my abundance.

60. I relax into creating abundance in ways that are easy and fun.

61. I enjoy the process of realizing my dreams.

62. I am ready, willing, and able to embrace success in my life and business now.

63. I am ready for success.

64. I am ready, willing, and able to embrace all opportunities in my life and business.

65. I say yes to opportunities, even when they seem scary.

66. I open myself up to receive success and opportunity in my life and business now.

VALUE AND SELF WORTH

1. I am worthy of happiness, and success.

2. I have something valuable to offer the world.

3. I'm worthy of achieving my business goals.

4. I value my products and services and what I have to offer.

5. I have something wonderful to offer the world.

6. I have valuable knowledge and skills that I apply to my business.

7. I fully embrace all the knowledge and experience I got from [previous company/business].

8. I already know everything I need to start my own business.

9. I'm worthy of working with clients with more money than me.

10. I'm worthy of working with wealthy, successful people regardless of my income.

11. I am good enough.

12. I deeply appreciate and accept myself.

13. I am unique and I love my uniqueness.

14. My message is valuable and people want to learn from me.

15. I'm good enough in every way.

16. I see the value in what I have to offer and I easily communicate it to others.

17. I am good enough and I am confident in all kinds of business company.

18. I value myself and my connection to Source.

19. I deserve good things in my life.

20. I am happy with the way I am.

21. It's okay for me to be myself.

22. I always have something valuable to offer.

23. I am innately valuable.

24. I am a [wo]man of immense talent.

25. I am worthy of having a successful business.

26. My knowledge is extremely valuable and people pay me for it.

27. It's safe for me to be myself in my business.

28. It's easy for me to be authentic in my business

29. I am unique in my own way and I am the only one who can offer what I do how I do.

30. I let go of self-criticism and replace it with self-acceptance.

31. I am free to be me and to run my business how I want.

32. My story is important and so am I.

33. I am a unique, special, creative, and wonderful person.

34. I am worthy of serving myself and others.

35. I am worthy of this successful business and life.

36. It's safe and appropriate to be myself and to believe in myself.

37. I am proud of who I am.

38. I am thankful for the advantages that I have.

39. I am grateful for who I am.

40. I value the contribution I make in the world.

41. I have valuable things to say that can help people.

42. My ideal clients want to hear what I have to say.

43. I already know enough and I have enough experience to serve my clients well.

44. I am complete as I am.

45. I fully step into the value that I bring to my business.

46. The person I look up to and respect the most in the world is me.

47. I am my biggest fan.

48. I attract only the people who can see the value in and benefit from my work.

49. I value the characteristics that make me different.

50. I am enough.

51. I deserve to be massively successful.

52. I make a unique and specific contribution.

53. It's easy for other people to see the value of my contribution.

54. I'm already more than qualified to do the work I do.

55. I'm already ready.

56. I have the ability to help so many people.

57. It's safe and appropriate for me to be myself.

58. It's safe and appropriate for me to be unexpectedly different.

59. I deeply and completely accept myself for who I am.

60. I firmly believe in and express my worth.

61. I have a deep inner awareness and confidence in my self-worth.

62. I have unwavering confidence in the value I offer.

63. I have unwavering confidence in all my pricing.

64. I am worthy of charging whatever prices I want.

65. My time and experience are valuable.

66. I'm clear about the value of my work and I consistently attract the right clients to me.

67. It's easy for me to truly accept all of who I am, and I do.

68. I am worthy of people showing up for who I am.

69. My realness is one of my most beautiful aspects.

70. I appreciate all the work that I do.

71. I deserve miracles.

72. I am fully qualified to know what I know.

73. I give myself my own stamp of approval.

74. I am good enough, qualified enough, and official enough.

75. I am perfectly acceptable just as I am today.

76. I easily see and experience the fullness of my gifts.

77. I easily accept myself and others, free from judgement.

78. I'm wise enough to do all the things I want to do.

79. It's safe to be me, just as I am.

80. I am smart enough to be famous.

81. I am worthy to be prosperous.

82. I am trained enough to do all that I want to do.

VISIBILITY

1. It's safe and appropriate for me to stand out and be visible.

2. I love standing out from the crowd like a tall poppy.

3. It's safe to stand out in new ways.

4. I feel comfortable being different from others.

5. I feel safe being different from other entrepreneurs.

6. It's safe and appropriate for me to be a business star.

7. I am ready to be seen both online and offline.

8. It's easy and effortless for me to claim my space in the world.

9. It's safe for me to be seen anywhere.

10. It's easy for me to share value on video.

11. My stories show people what's possible for them.

12. It's easy to make myself heard and participate in groups.

13. It's safe and comfortable for me to be visible and in the spotlight.

14. I feel confident and happy with myself when people look at me.

15. I am ready to put myself out there with my new business.

16. I am safe even if I have online haters and trolls.

17. People find it easy to find me because I am easily accessible both online and offline.

18. It's easy for me to speak up spontaneously.

19. It's safe and appropriate for me to be the center of attention.

20. I am a natural on camera and people love my videos.

21. It's safe to stand out and be an expert in my field.

22. I feel confident when filming videos and it's easy for me to watch myself on video.

23. It's okay to be out there in front of people telling my story.

24. It's safe and appropriate for me to shine online.

25. It's safe for me to shine my light out into the world.

26. I love the feeling of shining like a star.

27. I am inspired by the accomplishments of others, and others are inspired by mine.

28. I naturally find it easy to be visible, even in new situations.

29. My timing in my videos is impeccable, and I always know what to say.

30. I deeply appreciate and accept my efforts to be more visible with my business.

31. I am proud of how my visibility has increased both online and offline.

32. I accept my imperfections in my writing and my videos.

33. It's easy for me to create inspiring, popular videos.

34. I allow myself to be vulnerable in my writing and my videos.

35. It's easy for me to express my uniqueness online.

36. I have a large audience which listens to what I have to say.

37. It's safe and appropriate for me to be me and to express who I am.

38. It's my purpose to show up in the world and share my story.

39. I am seen and valued for my expertise.

40. I'm seen and acknowledged for my achievements.

41. It's my time to be in the spotlight, and I'm ready for it.

42. My audience is ready for me to put this out in a big way.

43. I inspire people all over the world with my work.

44. I am a big business celebrity with a raving tribe of fans.

45. I speak with clarity and strength.

46. I shine my light out into the world and attract my ideal clients.

47. I have a thriving online tribe of people who jump to buy my things.

48. I'm fully comfortable in the spotlight.

49. I'm ready, willing, and able to receive judgement.

50. I love pitching myself for PR and media opportunities because it gets me clients.

51. I love being visible with my business.

52. I enjoy publicly celebrating my accomplishments.

53. It's easy for me to share my accomplishments with others.

54. It's easy for me to speak up and ask questions.

55. I express myself fully in a loving way.

56. I easily bring out those things that are most profound inside me.

57. It's easy for me to outwardly express and externalize my divinity.

58. I'm safe when I'm tall and elevated.

59. I'm safe when I ascend to a high space.

60. I am here to be big and visible.

61. My divine mission is to help people on a global level.

62. I stand out energetically in a very big way.

63. My destiny is to stand out globally.

64. People want to hear what I have to say.

65. I own my presence on a big stage.

66. I claim my space on the big stage.

67. I expand my vision globally.

68. I embody all of who I am when I am on stage.

69. I'm a great podcast guest that everyone wants to interview.

70. It's easy for me to be accepted as a guest on other podcasts.

71. People love it when I show up as my unique self.

72. It's safe and appropriate for people to disagree with me.

73. It's safe and appropriate for people to criticize me.

74. It's safe and appropriate for me to speak my truth.

75. It's safe and appropriate for me to be powerful and known.

76. I have a steady stream of media outlets approaching me.

77. The media sees me as an expert in [your field of expertise].

78. I am famous for [your field of expertise].

79. I am THE go-to person for [your field of expertise].

80. I clearly express myself openly.

81. People flock to hear me, see me, and be in my tribe.

82. It's safe and appropriate for me to be different.

83. I easily radiate my gifts out to the world.

84. I give myself permission to share my gifts far and wide.

85. I easily speak up and express myself fully.

86. I share my message in a way that's aligned with my higher self.

87. It's safe and appropriate for me to share what I know with the world.

88. I easily radiate my brilliance as a messenger of truth.

89. It's safe and appropriate for me to reveal the brilliance of my light.

90. I easily show up in the fullest expression of myself.

91. I easily allow myself to take up space to shine.

92. The more I shine my light, the more I connect with others.

93. It's easy for me to radiate brilliance and vulnerability.

94. It's easy for me to connect with my audience and expand my reach.

95. I am loved, noticed, and appreciated.

96. I am ready, willing, and able to be seen.

97. I am ready, willing, and able to take up space.

98. I am ready, willing, and able to appear regularly in people's timelines.

99. It's easy for me to build a thriving community, both online and offline.

100. Speaking opportunities come to me easily and regularly.

HOW TO CREATE YOUR OWN BELIEF STATEMENTS

"Far better than a precise plan is a clear sense of direction and compelling beliefs. And that lies within you. The question is, how do you evoke it?"

— DEE HOCK

The important thing when creating belief statements is that you use language that feels and sounds right to you. They need to be meaningful, and they need to sound like something that you would say or write. This means that you'll probably want to adapt some of the statements on the previous lists to suit your style, and you'll probably want to create brand-new statements at some point. Here's how you can do that.

The quick way

First, take a look at where you are in your business and life, and ask yourself some questions. What are you currently experienc-

ing? What's currently going on that you don't like? What are you afraid of? What are you procrastinating on?

Next, flip the issue on its head and ask yourself some more questions. What would you rather have instead? How do you want things to be? What do you need to believe to have this? Who do you need to be to achieve this?

From there, create your new belief statements around what you *do* want. These statements should adhere to the following criteria:

1. **First person.** You want to speak in terms of what *you* want: "I am good enough as I am."

2. **Present tense.** Your subconscious mind lives in the present, so avoid speaking about the past or the future. Again, "I am good enough." Not, "I will be good enough after I finish my training course."

3. **Positive.** You want to focus on what you *do* want, and not on what you *don't* want. "I am good enough." Not: "I don't feel inferior to others."

4. **Concise.** The statements need to be short and easy to remember. If you find yourself creating long, difficult statements, try to find a way to split each statement into two parts. "I am good enough." Not: "I let go of my need for perfection and I am good enough in every single way, and I wake up feeling excited to be my unique self every single morning." Try memorizing that one, and then repeating it over and over again. Not easy!

Let's focus on doing things the easy way. Split that goal up into three parts: "I let go of my need for perfection." "I am good enough in every single way." "I wake up feeling excited to be my unique self every single morning." Remember: the processes and techniques I've recommended are fast and easy. It's better to split a complex statement into thirds and spend five minutes reprogramming each of the three beliefs than it is to create one giant, awkward belief that you struggle with.

5. Emotional. Focus on creating statements about topics or issues that you're really passionate about. "I am good enough" may or may not be exciting to you, even if it sounds like a great thing to believe. Perhaps you would be better off re-wording the belief to something like "I'm blessed and grateful to be me." Or "I love myself just as I am." Or "I deeply and completely love and accept myself for who I am." Use your own words to make it meaningful.

6. Language. Again, the statement needs to be in your words. This is slightly related to the previous point, so if "I am good enough" is not the kind of language that you would use, adjust the statement to something similar, like "I value myself as I am today." Also, if English is not your native language, or it's not the language you think in or use in your everyday life, consider translating the statements into whatever language you prefer.

THE LAST TWO points apply to every single belief statement in this book as well—that's why I left spaces between each belief statement in the lists. If you come across a statement that you like, but it doesn't feel quite right, take a minute to re-word it so

that it feels really exciting to you. Also, if a concept sounds good, but it uses language that you wouldn't normally use, re-work the statement so that it sounds like something you would actually say or write.

This is all about *you*, and what statements are best for *you*. That should be clear by now, but I feel the need to repeat myself (again). You know best, even if you may have forgotten that.

~

The deeper process

Sometimes we can benefit from going even deeper to get our belief statements. Years ago, I created a signature program to help you take a good look at who you are, where you are in your business and life, and where you're going. These three areas will help you to dig deeper and get a clear vision and feeling for what you want in your business and life, and what your blocks are. In this program, I walk you through a clear system to answer these three questions and to help you get absolute clarity.

While it's not currently available as an online program, I've got many blog posts on the topic (which I call The Three Questions), as well as several podcast episodes.

Here's what it looks like, step by step. It starts with The Three Questions:

1. Who am I?
2. Where am I?
3. Where am I going?
4. Inner work
5. Action plan

Other ways

There are plenty of other ways to get creative and write your own belief statements that are meaningful to you. Here are some other ways I do it:

Weekly Akashic Records emails. The Akashic Records are an extensive library of energetic records of all souls, including their past, present, and possible future lives. It includes all events, thoughts, words, emotions, and intentions ever to have occurred in these past, present, or possible future lives. It's like an archive of each person throughout all their lifetimes. It is thought that each soul has its own Records, like a set of encyclopedias where each book in the set represents a single lifetime. It's the history—and future—of you, as a soul. I regularly subscribe to Vickie Young's weekly, personalized messages from my Records Keepers (www.medicinedreamhealing.com/my-weekly-messages/), and they've been very helpful in keeping me on track and stretching myself into new levels. When I receive my weekly email, I print it out and paste it in my journal, where I journal on the topic. I often create belief statements around the topic of the email, to help me fully embrace the content of the message.

Journaling. I often write in my journal about things that I'm experiencing, things I want to achieve, and how I want to grow. From these journal entries, I create belief statements that will help me to achieve my goals.

Sessions with my business mentor. I get so much out of each session with Lisa Wechtenhiser that I end up with at least eight pages of notes from each hour-long session. From there, I go through the notes and create belief statements to support the things I need to believe so I can take action and work on the things that came up in each session.

I always pay attention throughout my work day to the things I hesitate doing. I look at the things I'm procrastinating on, and I write them down. I used to keep a small notebook next to my computer to write down everything that came up for me during the day, and in the evening I would spend some time doing the mindset work to change my beliefs around those areas.

Take action today

Create some of your own belief statements based on what you want or need to believe. Make a list of at least ten statements, following the criteria in this chapter.

On the podcast

You can find the full list of podcast episodes here: www.hollyworton.com/podcast

- 317 Holly Worton ~ Know Yourself: How to Answer the Question of "Where Am I Going?"
- 316 Holly Worton ~ Know Yourself: How to Answer the Question of "Where Am I?"
- 315 Holly Worton ~ Know Yourself: How to Answer the Question of "Who Am I?"
- 297 Holly Worton ~ Personal Power: Why You Need It & How to Get It
- 221 Holly Worton ~ How Your Money Mindset Relates to Your Business Mindset
- 170 Denise Duffield-Thomas ~ How Upgrading Your Money Mindset Can Transform Your Business
- 157 Holly Worton ~ How to Increase Your Visibility by Transforming Your Mindset

MOVING FORWARD

"I think anything is possible if you have the mindset and the will and desire to do it and put the time in."

— ROGER CLEMENS

I hope you've found this book to be useful. I've tried to keep it short and simple, so you can quickly and easily get started playing around with muscle testing, which will help you to tap into your subconscious and get to know which beliefs you hold at this deep level. Awareness is the first step, and actually changing your beliefs at the subconscious level is super important if you want to upgrade your business mindset.

If you're in any way hesitant, think about the following: What is it costing you to avoid doing this deep mindset work? It's so easy to put off and just keep doing what you've been doing. But what will your business be like six months from now if you don't take action? If you don't get clarity on what mindset shifts you need to make? If you don't make those changes?

It's time to let those mind gremlins out of their cage—

where they're trapped in your subconscious mind—and transform them into helpful little...mind elves?

Take action today

Are you wondering exactly what you need to do now? I've broken it all down into five easy action steps. As the above quote reminds us, we've got to take action and put the time in. Transforming our mindset doesn't need to be difficult, but it isn't exactly magic. It does require an investment of time and action, and sometimes money.

Here's how to get started:

1. Identify the core beliefs that you need to shift in your business mindset, using the methods described in this book (muscle testing on the belief statements).
2. Find the best process or technique for you to change your mindset at the subconscious level.
3. Find the best practitioner or facilitator to help you with this mindset transformation.
4. Do the inner work to transform your mindset.
5. Take action to reinforce your new mindset.

1. Identify the beliefs you need

Identify the core beliefs that you need to shift in your business mindset, using the methods described in this book. Muscle test on the most important belief statements, adjust the wording if needed, and make up your own if there's something you'd like to shift that hasn't been covered in this book. Spend time journaling to get clear on what you want to experience, and what you need to believe in order to make that happen.

2 and 3. Find the best process and practitioner

This may involve trial and error. If something doesn't feel quite right, then don't go back again. You don't owe them anything. Listen to your gut feeling on this, and if you don't see changes fairly soon, you might want to reevaluate whether you've found the best method (or practitioner) for you.

After hearing so many great things about PSYCH-K®, I was tremendously disappointed in the first facilitator I saw. It was a terrible session, and I never went back to see her again. I then sought out another facilitator, but she convinced me to try ThetaHealing® instead, which I did enjoy, but I still wasn't working with the process that I wanted to try. Finally, I found a facilitator I liked and had an excellent session with her. A week or so later, I trained in the PSYCH-K® Basic Workshop.

The point of this story is that there are many processes and techniques out there, and there are many facilitators and practitioners of each one. Sometimes it can be tricky to find what's right for you. It can take trial and error. That's why I haven't included a specific process in this book: what works for me may or may not work for you. And besides, even if I were to teach you a process like Heart-centered Energy Work®, that would be a whole book in itself.

Some of the processes and techniques you might like to try include: Heart-centered Energy Work®, PSYCH-K®, ThetaHealing®, Emotional Freedom Techniques® (EFT or tapping), NLP (Neuro-Linguistic Programming), TAT (Tapas Acupressure Technique), Ask & Receive, hypnotherapy, and more. I've also experienced sound therapy sessions and light language sessions. In 2019, I graduated from a Shamanic Plant Spirit Healing Apprenticeship, which does exactly what it says in the name: it taught me how to work with plant spirits for healing (which, of course, can also help to free ourselves from limiting beliefs).

Change can be *very* quick when you're working at the subconscious level, so there's no need to attend weekly sessions for months before seeing results. Stay alert, and pay attention to how your life and business are different since you started doing the mindset work. Sometimes big changes occur, but people don't notice them, because things are going well and they're no longer experiencing whatever it was that they wanted to let go of. That's why it's so useful to write things down in a journal.

4. Do the training yourself

I always recommend that people train in a process or technique themselves so they can do the work on their own. There is great power in being able to transform your own beliefs whenever you want, wherever you want, however you want. I have spent the past several years working on my beliefs on a regular basis (at least once a week!), and I also see other professionals from time to time. In my experience, this is the perfect combination to approach changing our business beliefs.

If you've found a process that you particularly like, train in it and learn how to do it for yourself. This will require an initial investment, but it will save you time and money in the long run. You'll be able to make big changes in your belief system, and you'll be reaping the results in your business. This is what I mean when I say "do the inner work."

5. Take inspired action

When I work with clients, I always help them create a short action plan at the end of each session. This is important: no matter how much work we do to transform our beliefs and our mindset, we also have to take practical action. We can change

as many beliefs as we want, but if we don't actually *do the work* in our business, we won't automatically create change.

We still need to write the blog posts, do the videos, market our business online, and make the sales calls.

I always say this is like climbing a spiral staircase: the left step is the mindset work, the right step is the practical action. Left, right, left, right, and up we go as we build our business.

In the next chapter, I talk a little bit about how you can work with others if you feel drawn to do so. If not, I encourage you to read through the chapter anyway, so you can at least have some point of comparison to other professionals that you may choose to work with. It helps to have an idea of how different people work so you can find what's best for you.

Remember. . .*you* know what's best for you! There's a reason I keep saying this: we can have the tendency to give our power away to others, but deep down, you're the one who knows what's best. Go with your gut feeling or with whatever your heart says. That's your higher self checking in with you to let you know which option is best.

On the podcast

You can find the full list of podcast episodes here: www.hollyworton.com/podcast

- 295 Sharon Lock ~ How to Make Mindset Work a Habit
- 245 Holly Worton ~ How to Spring Clean Your Business + Mindset
- 230 Holly Worton ~ How to Make Mindset Work a Habit
- 276 Holly Worton ~ How to Create Your Own Personal Formula For Mindset Work & Healing

NEED MORE HELP?

"Whether it's your family, friends, community that you connect with, don't be afraid to reach out. That's my biggest advice that I can say for anyone going through any kind of obstacle or trials or tribulations. Don't be afraid to reach out and ask questions. Ask for help, because you never know where you'll find it."

— Vanessa Williams

Are you feeling stuck? If you've read this book, and are still feeling like you need more help engaging the power of your inner wisdom, read on. Or perhaps you've taken the five inspired action steps, and you uncovered some fears, blocks, or limiting beliefs that have gotten in the way of you upgrading your business mindset. If that's the case, get help.

Is this you?

Are you a coach, a healer, or a holistic therapist? Maybe you've got another type of business, and you're on a mission to change the world through the work that you do. You may be just starting in business, or you may be in the process of growing your existing business.

But you've hit a rough spot. You've done all the business and marketing training, but somehow things just aren't flowing for you. You're feeling stuck and frustrated.

All you want is more clients so you can help more people (and, let's face it, make a decent living from your business). You're starting to realize that being successful in business isn't just about knowing how to market and run a business. It's also about your mindset: making sure that your beliefs and your inner dialogue are aligned with your vision and goals.

But it's not always that easy.

Maybe you're struggling with:

- Lack of confidence, which leads to you procrastinating on getting your Most Important Tasks completed.
- Fear that people won't get what you do. They won't want it, or else they won't be willing to pay you for it.
- Issues around visibility and fear of standing out in the online crowd.
- Fear of overwhelm if you do attract all the clients you want and build a thriving business.
- Getting started with social media marketing, speaking, videos, and webinars—the thought of any of this makes you cringe.

- Believing you have something precious to offer. I
 mean, you know you do, but—do you?

Have you ever experienced any of this?

If so, you're not alone. I struggled with this stuff when I started my second business, and until I found a solution to all of this, my business suffered.

Fortunately, I found an easy solution to all of this. One that's fast, effective, and painless. It transformed my business, and it changed my life.

Imagine how it would feel if:

- You only attracted great clients: people who know what they want and they value what you do.
- You felt nourished and fulfilled by your business, confident that you were making a difference in the world, client by client.
- You had a tribe of raving fans who were eager to sign up for your new product or service launches.
- You had a clear vision for your business that felt aligned with your purpose: 100% you.
- Your business felt like it was in flow, with a regular stream of clients ready to invest in what you have to offer.

Sound good?

This scenario is what I want for you. I want to help purpose-driven women entrepreneurs create the business of their dreams that allows them to live the lifestyle they want.

As I mentioned earlier in the book, I've stepped back from doing one-to-one sessions so I can focus on my writing. However, I do offer occasional sessions, as well as done-for-you mindset and energy work, in my Patreon community.

Check it out at:
www.patreon.com/hollyworton

Please get in touch if you have any questions:
holly@hollyworton.com

Podcast

As you've seen at the end of some chapters, I've got many
podcast episodes on mindset. These episodes are a great way to
deepen your understanding of your mindset and find new ways
of transforming your business beliefs. Most podcast episodes
have full transcripts available on the website, either to read
directly or as a free pdf download (no email required).

One-to-one work

If you're ready to get started with one-to-one sessions right now,
I have some recommendations for you. These are five women
that I trust entirely and often go to for sessions myself. They all
work online via Skype/Zoom.

I highly recommend these five facilitators:

- Cara Wilde: http://carawilde.com
- Cazzie Dare: https://yearning4learning.co.uk/
- Claire Baker: http://happyhealthyempowered.com/
- Jo Trewartha: http://freeyourmindsolutions.com/
- Sharon Lock: http://sharonlock.com

Take Action Today

1. Check out my Patreon and see if you're interested in
 how I can help you there.

2. Subscribe to my podcast (Into the Woods with Holly Worton) and listen to the episodes on mindset.
3. Find a process or technique that resonates with you and a facilitator to have sessions with.
4. Once you find a technique that you love, train in it so you can use it to work with yourself.
5. If you want to do a deep dive into your business beliefs, buy the *Business Beliefs* workbook.

TESTIMONIALS

I 'm including testimonials from my clients so you can get an idea of the results you can achieve from doing work to transform your mindset at the subconscious level. Again, I rarely do one-to-one sessions, so this isn't about me trying to sell to you. It's about new possibilities. Remember, find the best method to use for *you*, and find the best professional for *you*. There's no one solution for everyone.

I was so hopeful for results when I signed on with Holly, as I opened a business about 6 months prior. My financial and physical stress were through the roof, until Holly guided me to changing the appropriate belief statements. I have **no more chest pain, no more heavyweight stress** on my shoulders, and **my most recent month's collections at the office was $80,000! I am a magnet for money and success!** Thank you Holly! xo

— Elizabeth D. Walker DMD, MSD

I have undertaken more traditional coaching before and

found it useful but I wanted to really tap into a deeper way of working—particularly accessing the subconscious level. **I found the HEW process really powerful** during each session and focussing on how I felt during the session (and afterwards) helped tap me into other things. My instinct was to work with Holly because I resonate with a lot of the points she makes in her videos and podcast and she is a really warm person. It was also important to me that I felt like Holly was working through a lot of the same issues that were coming up for me. This authenticity was really important to me. I would definitely do more work with Holly in the future and would recommend working with her to others.

— LOUISA WHITNEY

When I first found Holly, I was struggling to get my business to a place of success. I had the foundation in place, and had done all the "right" things, but somehow, it still wasn't working . . . for me. I felt like I had a mindset limitation holding me back. After my initial meeting with Holly, even before our first working session, I received $16K in unexpected personal income—debts repaid, a royalty check, a bank refund . . . after only two working sessions, I booked $43K in sales for my business, and I quit my job. That was a dream I had held for over two years, and had been working for. It wasn't magic, I put the work in, had a funnel, ads and sales conversations all set, but the results from working with Holly were literally overnight, and amazing. So much so, that had you told me that this would be happening . . . to me . . . I would never have believed you. . . in a million years. Working with Holly is seriously one of the best investments in my business and my life, that I have ever made. Thanks Holly.

— JULIE LANGUILLE

Working with you has made a huge difference. In fact, I think it's made all the difference. Even if things don't feel comfortable I still persevere.

— NATASHA MANN

I've had some really beneficial results from the session. The changing of beliefs about myself is really working. For the first time since I started working for myself I have confidence in the value of my services and the prices I'm quoting. It's an amazing process.

— GILL HUNT

Holly's assumption of unlimited potential and possibilities in her clients, gives her a laser focused ability to spot false limitations. Holly combines her skills with compassion and sensitivity which allows you to share yourself at a deep level. Her passion for PSYCH-K and her commitment to walk her talk makes her a leader in field. I recommend working with her in a heart beat.

— CARA WILDE

Since working with Holly and fully owning what I'm really about my business has been going through a big change. The transformation and higher consciousness work to help entrepreneurs find their natural Flow and abundance is now taking centre stage.

It's not only easier to share what I do now because I'm just being myself, but I created a successful online programme called The Flow Project, I've been interviewed for podcasts and invited to speak at events on the topic, and opportunities to collaborate on projects incorporating spirituality in

business are opening up all the time! It feels like I turned a major corner and my business has become really exciting!

— Cathy Ballard

Holly, PSYCH-K and more importantly your kind, generous way of practicing it have been fundamental in my decluttering once and for all. OMG the peace I feel is amazing. What else can I say but THANK YOU.

You have really helped me to see and work on some fundamental issues that have kept me from moving forward with my business and my life. YOU are the bomb.

— Bibi F.

Despite over the years of my own journey of personal growth and working on myself there was one major thing that just wasn't shifting, and it was a constant negative effect on my life that I could never quite break free of despite having tried lots of things. The weird thing is that the issues that Holly worked with me on just sort of dissolved. These were big issues of a traumatic nature that it felt like my emotional and physical body just didn't want to let go of—but after working with Holly these things just melted away. What's amazing is how quickly I saw this profound change.

— Catherine Watkin

I feel more confident that I will be able to develop and achieve my dream business and attract my ideal clients. I also am experiencing more clarity about how to use social media and know that I will overcome any blocks or obstacles. Since the session I do not feel that sense of fear and paralysis when I start to approach the social media format or platforms. I feel

and know the changes on a physical, emotional, energetic and spiritual level. This was the best thing I could have done for myself and my business.

— JACQUELINE CONROY

Holly's process is absolutely phenomenal. I can hardly believe **how quickly things start to change** after we have a session— **I've seen results as soon as hours after working with her**! Somehow after we clear what needs to be cleared and call in what I desire I see opportunities that I missed before, move forward on ideas that I've been sitting on, and say yes to exactly the right things. It's like during a session with Holly **I realign my energy to match what I want to experience** – and so when we're done what I want can't help but appear in my world. **Absolutely magical**, do your future self a big favor and book in with Holly now!

— JOANNA HENNON

NOTES

BUSINESS BLOCKS

The following is an excerpt from my book *Business Blocks: Transform Your Self-Sabotaging Mind Gremlins, Awaken Your Inner Mentor, and Allow Your Business Brilliance to Shine.* It's available soon in ebook, paperback, audiobook, and workbook formats.

∽

"You can't just declare that you have a growth mindset. Growth mindset is hard."

— CAROL S. DWECK

As I said at the end of the last chapter, you need to do the work to transform your mindset. It doesn't happen on its own, no matter how much you engage in positive thinking. That's why I chose the above quote to introduce this chapter. Personally, I don't think that having a growth mindset is *hard*, but I do think it takes *work*. Again, not necessarily *hard* work, but you certainly need to put both time and effort into transforming your mindset.

This chapter title may sound a bit dramatic, but let's face it: business blocks can be hard to uncover if we don't have any sort of guidance or clear system for doing so. And most people (unfortunately) don't have a way to easily access their blocks. This is something that I developed over the course of several years, and it's a combination of things I learned through training in various processes and techniques and also through practical experience with transforming my own mindset and helping clients transform theirs.

As I mentioned before, when your subconscious mind is on board with your conscious vision for your business and life-style, all is well. It's easy to take action and achieve your goals. But when your subconscious *isn't* on board, that's a whole different story: that's when your day to day life is filled with fears, blocks, and limiting beliefs that hold you back from taking action toward your business goals.

Have you ever felt totally stuck in your business? Maybe you've been taking action, following the advice of the latest business gurus or working with a business coach or mentor. Or maybe you've been totally stuck, procrastinating on your to do list and spending your days wasting time on social media when you could be using it to market your business. I think we've all been there at one point or another. It's rough.

Either way, something isn't working. Maybe the business guru's advice isn't really aligned with your own beliefs and style, so your efforts come across as awkward to your followers. And if you're just wasting time on social media, well...that's just time that's been lost, and deep down, you know it. And it doesn't feel good.

It's what we often refer to as self-sabotage, although I always hesitate to call it that—you aren't *actually* sabotaging yourself. Rather, your subconscious mind is trying to keep you safe within your comfort zone. It's got your best interests in mind...kind of. On one hand, it wants you to be safe; on the

other hand, many of the actions we need to take to create our dream business take us *outside* our comfort zone. When our subconscious is "sabotaging" us, it can lead to procrastination and feeling stuck and frustrated in business.

That's why it's so important to understand exactly what your business blocks are: so you can identify them and transform them. Toward the end of this book, I'll talk about how you can actually transform your business blocks into business bliss. There are so many options for releasing blocks at the subconscious level, and you just need to find the right process or technique for you.

This book is complementary to my *Business Beliefs* book. You don't have to read them in any particular order, but they work together to help you uncover your current mindset, including your existing fears, blocks, and limiting beliefs. Start with one of the books, do the mindset work on what you've uncovered, and then work through the second book to go even deeper.

For now, we're going to take a look at how to discover your business blocks, and then we'll take it even deeper by going through a list of fifteen different categories so we can really get to the root of all the various business blocks you may be experiencing. It's important to be open and curious about this: try to accept of your blocks, rather than reject them or repress them. Don't be ashamed of them, and don't be alarmed—your blocks are easy to change, but before you can change them, you have to know exactly what they are.

Sometimes we have the tendency to pretend these blocks don't exist, or to sweep them under the rug. If we do that, they won't go away. They'll just be buried deeper and deeper into our subconscious minds, where they will continue to do damage. Only it will be more difficult to do something about them.

The point of this book is to actually dig all this "mind crap"

up, take a look at it, and then use this valuable information to transform the blocks into bliss. It can be done, and it's not as hard as it sounds. In fact, it can be easy and effortless. But first, you've got to do the detective work. In the same way that *Business Beliefs* was about bringing to light the positive beliefs that will enhance our lives and our business, this book is about uncovering the shadow side of our mindset. It's important to do both kinds of work.

Are you with me? I promise I'll try to make this as painless and as uplifting as possible. However, *you'll still need to do the work yourself.* Have I made that clear yet?

ABOUT THE AUTHOR

Holly Worton is a podcaster and nine times published author. Her latest book, *If Trees Could Talk: Life Lessons from the Wisdom of the Woods*, went straight to the top of 16 Amazon bestseller lists, and she has been featured on BBC Radio Scotland and on prime time national television in the UK—on ITV's *This Morning*.

She helps people get to know themselves better through connecting with Nature, so they can feel happier and more fulfilled. Holly enjoys spending time outdoors, walking long-distance trails and exploring Britain's sacred sites. She's originally from California and now lives in the Surrey Hills, but has also lived in Spain, Costa Rica, Mexico, Chile, and Argentina. Holly is a member of the Druid order OBOD.

Holly ran her first business for ten years, building it up to become a multi-million-dollar enterprise. When she went into the coaching world she was confident that she had the business and marketing skills she needed to set up a new company. And she did – but she struggled to grow her new venture quickly because she encountered fears, blocks, and limiting beliefs that she didn't even know she had.

She discovered that pushing forward and taking action just wasn't enough. She needed to transform her mindset and release her blocks, as this was the only way to take the *right* actions to move her new business forward. Thus began her journey of intense personal development through deep mindset work, which transformed her existing coaching busi-

ness into a focus on helping people with their business mindset.

Eventually, she realized that she wanted to devote her time to helping people through her writing, and she let go of her mindset business to focus on her books. Now, Holly continues to write about mindset, long-distance walking, and connecting to Nature. She is married and has two Maine Coon cats, Emma and Matías.

Podcast

You can find her podcast on Apple Podcasts, or wherever you listen to podcasts. Links to subscribe, as well as the full list of episodes, can be found here:

http://www.hollyworton.com/podcast/

Patreon

Join her online community where you can get discounts on one-to-one sessions, by joining her on Patreon:

https://www.patreon.com/hollyworton.

Books

You can find her other books, including her books on nature, walking long-distance trails and business mindset, wherever you purchased this book.

Newsletter

Finally, you can stay in touch by subscribing to her newsletter on her main website: http://www.hollyworton.com/.

amazon.com/author/hollyworton

facebook.com/HollyWortonPage

twitter.com/hollyworton

instagram.com/hollyworton

goodreads.com/HollyWorton

bookbub.com/profile/holly-worton

ALSO BY HOLLY WORTON

Business books

Business Beliefs: A Companion Workbook

Coming soon

Business Blocks: Transform Your Self-Sabotaging Mind Gremlins, Awaken Your Inner Mentor, and Allow Your Business Brilliance to Shine

Business Blocks: A Companion Workbook

Business Intuition: Tools to Help You Trust Your Own Instincts, Connect with Your Inner Compass, and Easily Make the Right Decisions

Business Intuition: A Companion Workbook

Business Visibility: Mindset Shifts to Help You Stop Playing Small, Dimming Your Light and Devaluing Your Magic

Business Visibility: A Companion Workbook

Nature books

If Trees Could Talk: Life Lessons from the Wisdom of the Woods

If Trees Could Talk: Life Lessons from the Wisdom of the Woods—A Companion Workbook

Walking books

Alone on the South Downs Way: One Woman's Solo Journey from Winchester to Eastbourne

Walking the Downs Link: Planning Guide & Reflections on Walking from St. Martha's Hill to Shoreham-by-Sea

Alone on the Ridgeway: One Woman's Solo Journey from Avebury to Ivinghoe Beacon

Walking the Wey-South Path: Planning Guide & Reflections on Walking from Guildford to Amberley

A REQUEST

If you enjoyed this book, please review it online. It takes just a couple of minutes to write a quick review. It would mean the world to me! Good reviews help other readers to discover new books.

Thank you, thank you, thank you.

Made in the USA
Columbia, SC
30 May 2020